Gunfight AT THE O.K. Corral

In Words and Pictures

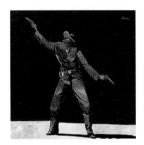

• Thom Ross •

Foreword by Paul Andrew Hutton

Fulcrum Publishing
Golden, Colorado

Library of Congress Cataloging-in-Publication Data
Ross, Thom.
 Gunfight at the OK Corral / by Thom Ross.
 p. cm.
Includes bibliographical references.
 ISBN 1-55591-184-6 (pbk.)
 1. Ross, Thom—Catalogs. 2. Frontier and pioneer life in art—Catalogs. 3. Outlaws in art—Catalogs. 4. Tombstone (Ariz.)—History. I. Title.
 ND237.R7246 A4 2001
 759.13—dc21
 2001002333

Printed in Hong Kong
0 9 8 7 6 5 4 3 2 1

Cover and interior design: Constance Bollen, cb graphics
Editorial: Marlene Blessing
Cover painting: *Confrontation at the O.K. Corral*, Acrylic on Canvas, 48" x 48".
 Copyright © Thom Ross; courtesy of the Martin–Harris Gallery.
Transparencies (photography): Patrick Bennett, Lloyd Shugart, Thom Ross
Background photos: Edgar Ross, Thom Ross

Fulcrum Publishing
16100 Table Mountain Parkway, Suite 300
Golden, Colorado 80403
(800) 992-2908 • (303) 277-1623
www.fulcrum-books.com

This book is dedicated to my two daughters,
Rachel Kathryn Ross
and
Olivia Ann Ross

With thanks for the faith you have in me as an artist,
for the loyalty you have shown me as friends,
and for the love you have for me as your father,
I proudly dedicate this, my first book, to you,
with my deepest love and affection.

ILLUSTRATIONS

Plates

ACKNOWLEDGMENTS

I want to thank personally the following people who have shown their dedication and loyalty to me for many years as a friend and as an artist, especially at times when that was a hard thing to do!

Delos Van Earl
Frank Londy
Maureen Londy
Rich Tarrant, Jr.
Robert Solomon

I would also like to thank the following people who have been along with me for the ride and who have lent a hand whenever it was needed: Alex Angelo, Mark Barron, Eric Bogel, Brynna Browne, Mark Costello, Ruth Costello, Bob and Mary Emel, Morgan Greig, Doug Hagen, Kim Hahn, Rhonda Jackson, Shari Johnson, Bill Klyn, Mac Macdonald, George C. Scott, Mike Shea, Sari Staggs, Bob Stanley, David Swift, Carla Swiggum, Colleen Thompson, Terry Yazzolino, and Gary "Rusty" York.

For bringing about the publication of this book, I want to thank Marlene Blessing and the people at Fulcrum Publishing for their faith in, and enthusiasm for, my work.

For their contributions in assisting me with this book I want to thank Paul Andrew Hutton, Paula Mitchell Marks, Bob Boze Bell, Jeff Morey, and Wyatt Earp.

A thank you is also in order for the galleries that have believed in me and that continue to carry my work:

Marty Kruzich and Ron Harris, Martin-Harris Gallery, Jackson, Wyoming

George and Diane Kneeland, Kneeland Gallery, Ketchum, Idaho

Geoffrey Sutton, Sutton-West Gallery, Missoula, Montana

Gunnar Nordstrom, Gunnar Nordstrom Gallery, Kirkland, Washington

Betty Wilde, Wilde-Meyer Gallery, Scottsdale, Arizona, and Tucson, Arizona

And finally a much deserved thank you to that group of long-suffering individuals who have had to live for so many years with me as son, brother, or relative: Emily Ross, Edgar D. Ross, Sr., Edgar D. Ross, Jr., Julia Kovi, Betsy Jones, and to my late grandparents Harold Hill Jones, Marion Burns Jones, Lillian Rothman, and Edgar Rosenberg (whose grave is less than 100 yards from the grave of Wyatt Earp!).

To the Earps, the Hollidays, the Clantons, and the McLaurys, living or dead, a sincere and long overdue thank you for the contribution to my life of something of which you are all a part.

FOREWORD BY PAUL ANDREW HUTTON

The saga of Wyatt Earp and the Gunfight at the O.K. Corral has become, in the hands of artists, novelists, popular historians, and filmmakers, a remarkable American epic. Earp has been firmly entrenched in the pantheon of America's most famous heroes—the symbol of the incorruptible town-taming western lawman—while the gunfight has served as the prototype for every frontier showdown painted, written about, or filmed since the 1930s. Good versus evil, civilization versus savagery, law versus anarchy, justice versus retribution, urban versus rural, progress versus tradition, the past versus the future—all themes that have made the frontier story so central to America's story.

Few tales from our history have been as visual, and thus so compelling for the artist. This has never been more true than now as we enter a new century so totally dominated by the visual image. There are a handful of powerful images from our collective past that—thanks to artists and filmmakers—come immediately into the mind's eye. Washington crossing the Delaware, the Alamo, Lincoln's face, Custer's Last Stand, the *Titanic* sinking, Pearl Harbor ablaze, the raising of the flag at Iwo Jima, the atomic bomb cloud over Hiroshima—all are images seared into our collective consciousness by subtle but constant repetition. The Gunfight at the O.K. Corral is one of those images.

So it is altogether fitting that artist Thom Ross has chosen the gunfight for his first book—the visual feast you have before you. Ross, who is a fanatical student of western history, knows the facts in excruciating detail but also clearly comprehends the mythic qualities of the story. His art—at once historically realistic while still artistically abstract—perfectly blends myth with history to capture the color, fluidity, and symbolic power of this singularly epic moment from our western past.

Join us, then, on a journey to a different place and time. A place where the bright colors from a doomed past clash with the somber darkness of an inevitable future. A place of confrontation, violence, and quick death frozen in time. A place of history and of myth. Join us for that epic walk down a dusty street toward a destiny no one could have imagined. Join us at Thom Ross's O.K. Corral.

ARTIST'S STATEMENT

The Gunfight at the O.K. Corral is, for a "western" artist, a veritable motherlode of images from which to draw inspiration. The names of the town, the alleged site of the gunfight, and the participants all ring with a wonderful clarity as if something out of a novel. Due primarily to movies, none of which ever agree on all aspects of the fight, this most celebrated event from the Old West is one filled with contradictions. It is at once both part of our American myth and history, as well as an unsettled story, in which a swirl of issues and good guys and bad guys continue to perplex us.

I have long been fascinated by the story, ever since that day, long ago, when my dad read me the account of the fight from Stuart Lake's book, *Wyatt Earp: Frontier Marshal*. I was probably nine or ten years old, but I can still remember distinctly the blue-and-white checkered terry-cloth robe Dad was wearing as he read how the cowboys, in their gaudy clothing and huge sombreros, walked the dusty streets of this town called Tombstone. And then how the Earps and that friend of theirs, with the great name of Doc Holliday, blasted the cowboys to ribbons. I can still feel that same sensation of startled wonderment and absolute horror. It was then I became hooked on Wyatt Earp and the Gunfight at the O.K. Corral.

Over the years, I kept reading what I could about the fight, and slowly the story took shape for me; satellite characters became major figures whose place in the overall tapestry of the story began to make sense. I also found there were other stories interwoven with the gunfight. These started to appear in drawings and scribblings whenever and wherever I found something to draw on. (I readily recall drawing in the pages of my sophomore high school biology book, Wyatt Earp and "Curly" Bill Brocius blasting away at each other during their famous shotgun duel.)

In 1976 I attended a "Western Film Festival" in Sun Valley, Idaho. One film I saw was John Ford's *My Darling Clementine*. When it was over, I approached a microphone and asked a rather naive and youthful question: "How come they can't get it historically

accurate?" Sitting on the panel was Peter Fonda (whose father, Henry, had, of course, played Wyatt Earp in the movie).

He took my question and began to talk about the gunfight in terms of its mythical qualities. I had never really considered that aspect of the fight. When I viewed the film again, I had all the same complaints about inaccuracies. But this time, when the film was over, I realized that, although Ford got almost everything wrong historically, his creation was a great movie! It was then that I began to contemplate painting these events from history, but painting them for their mythical qualities.

As you go through this book, you may see paintings that don't literally correspond with the text that accompanies the piece. This is most obvious in depicting Tom McLaury (PL. 33, page 71). History tells us that he wore a blue shirt and a vest, and some witnesses mention a coat. Before the fight, Tom's shirt was tucked into his pants, but sometime before the fight took place, the shirt had been pulled out of his trousers and now hung below his waist, as if he were hiding a gun in his belt or waistband. In my paintings of Tom, sometimes I give him a coat, sometimes I give him a holster. . . . Sometimes I paint his shirt outside his trousers. Other times it is tucked in neatly enough to make his mother proud.

In the serigraph image (PL. 28, page 62), you will see that all participants are armed, even the johnny-come-lately Billy Claiborne. This is not an attempt to rewrite history or to confuse the viewer. It is rather an exercise in meaning and it poses the mythical question: How could you be at the celebrated Gunfight at the O.K. Corral unless you were armed!

The Earps appear pretty much the same, each of them almost identically uniformed in their frock coats and black suits, thus appearing as a solid, formidable force. Holliday is a much more colorful figure to paint, given that he had the only shotgun, which is such a frightening weapon. Plus he wore that long coat and scarf, all elements that give wonderful sweep and movement to a painting.

The Gunfight at the O.K. Corral took place on October 26, 1881. It was a very real event in which two men were wounded and three men were violently slain. Yet this does not totally explain our ongoing fascination with the fight itself. The showdown neither resolved anything, nor was it an end in and of itself,

as some movie versions suggest. The killings continued for months afterward. A close inspection of the reasons for the fight reveal, in many cases, some sordid characters caught up in drunken brawls, stolen merchandise, and violent shenanigans. That greed and power might be at the core of this showdown does not help us see the event as enlightening or spiritual. Yet there is a force at work here that transcends reality and makes this a cherished and celebrated event even today. And that force is the mythical dimension, what the gunfight might represent.

When I talk to people about the gunfight, I usually explain, as best I can, the history of what led up to the fight, the fight itself, and the grizzly aftermath. But I also discuss it as a symbolic event, open to interpretation by anyone. To some this was murder. To others it was an action to make the West safe for women and children. To me the O.K. Corral fight has another meaning, one that inspires me. (I am sure my parents are cringing as they read this! "The O.K. Corral gunfight as inspiration?!?! Where did we go wrong with that boy?!?!")

In my life, as in most people's lives, times can get hard, and disappointments abound. At such moments, when things looked tough, I began using the O.K. Corral in its mythic form as motivation to rise up and confront those obstacles that either frightened or threatened me. In my interpretation, the Clanton Gang takes on the aspect of the grim and troublesome forces that fill me with trepidation and concern. Opposite this "force" stand the Earps. Marshalling their courage, strapping on whatever weapons they need to protect themselves as they go to do battle with this obstacle (and it can be whatever you want it to be), the Earps march boldly and fearlessly to confront the dangers that await us all. (This personal interpretation is not a historical argument, nor is it meant to slander the Clantons and the McLaurys in any way. It is only that in the story's mythic form, these are the roles we seem to assign to each group.)

One of my chief arguments with most contemporary traditional "western" art that deals with the O.K. Corral is that the artists, almost without fail, attempt to get the scene "right." They concentrate on the clothing and the armaments, the time of day, the layout of the town, and so forth. Often the works achieve great accuracy. But for some reason they

always seem somewhat dull to me, almost lifeless. If the O.K. Corral is to have any meaning for those of us living in the twenty-first century, it must not continually be confined to the absolute realities of 1881. With this view in mind, I have tried to honor the myth, creating paintings less concerned with what actually happened in that corral in 1881—although I have never veered completely away from the facts. Instead I have focused on the shapes, colors, and composition that this specific gunfight drama offers. The results—a more contemporary or modern look, feel, and meaning for these characters and events, something that transcends time and place.

It is my hope that I have achieved some of my aspirations, and that readers of this book will enjoy an artist's vision of one of the most fascinating stories of the Old West.

GUNFIGHT AT THE O.K. CORRAL

This most celebrated gunfight from the annals of the Old West has been the subject of controversy ever since the gunsmoke drifted off Fremont Street that blustery October day in 1881. The question of who were the "good guys" and who were the "bad guys" is still debated today.

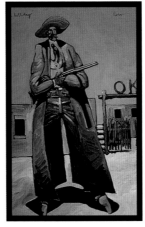

Tombstone, Arizona, was a mining camp split into political halves. Many of the townspeople who ran the local businesses were northern Republicans. Out on the range, the "cowboy" element was mostly made up of displaced southern Democrats. Naturally, folks on both sides had antagonistic feelings toward one another.

The outlaw faction in the area was engaged mainly in cattle rustling, particularly the rustling of cattle from south of the border. Their forays into Mexico often resulted in violence, gunfire, and murder. With increased efforts on the parts of both the governments of the United States and Mexico, cross-border rustling and retribution were effectively shut down.

As Tombstone began shipping out on the stage lines great amounts of wealth in the form of silver, the stage lines then became the focus of the outlaws' attention. Of the four Earp brothers in Tombstone, the oldest brother, James, was a bartender and remained out of the law enforcement business. Virgil, the next oldest, was a deputy U.S. Marshal. He would eventually become the city marshal of Tombstone and, in that capacity, he would lead his brothers to the confrontation at the O.K. Corral. Wyatt, the third of the five brothers, worked as a stagecoach shotgun messenger and gambler. Morgan also rode shotgun for the Wells Fargo stages. Often Virgil would deputize Wyatt and Morgan when he went in pursuit of criminals. (Fifth and

youngest brother, Warren, would not arrive in Tombstone until after the gunfight.)

It was the bungled robbery attempt of the Benson–Bisbee stagecoach in March 1881 that triggered the string of events that led up to the gunfight and beyond. In that failed robbery, four masked men tried to rob the stage but succeeded only in killing the driver, Bud Philpot, and a passenger, Peter Roerig. The county sheriff, John Behan, and Virgil Earp led a posse in pursuit of the outlaws. Behan was closely aligned with the cowboy element, and this caused a rift between Behan and the Earps. When one of the robbers was captured, he was placed in the Tombstone jail and, almost as quickly, went out the back door and disappeared into the night. This sort of episode pushed the animosity between the two law factions to a higher level of tension and distrust.

When Wyatt Earp then made a deal with cowboy/rustler Ike Clanton to betray the robbers, the stage was set for the shoot-out that was to follow. Before Clanton could turn over the robbers to Earp, who, for political reasons, wanted the credit for their capture and was willing to give Ike the reward money, three of the would-be stage robbers were slain and the fourth simply disappeared.

Ike Clanton now feared that Wyatt would reveal his attempted betrayal of his "pals." Tensions mounted until they erupted on the morning of October 26, 1881. That morning, Ike was drunk, bragging that he would kill the Earps as soon as they appeared on the streets. Virgil was notified of these threats but paid them no attention and went back to bed. He was not concerned with Ike's brag and bluster. But when the threats continued unabated, Virgil got up and tracked Ike down, smacking Ike over the head with his pistol and dragging the stunned Clanton off to court, where he was fined and released.

By now the other Earps, Morgan and Wyatt, were upset with these threats. When Wyatt bumped into cowboy/rustler Tom McLaury, he struck the young man over the head with his gun and left him writhing in the street. It was at this time that Frank McLaury and Billy Clanton rode into town from the range. When they learned what had happened to their brothers, they became so angry that they did not turn in their guns as the town law required. Frank and Billy met up with their

brothers, Tom and Ike, and discussed the situation as it stood. The Earps were now aware of the strong force the united cowboys presented.

The cowboys were then seen moving their horses from the Dexter Corral, across Allen Street, and into the O.K. Corral. At the next report, they were standing in a vacant lot near the rear entrance to the O.K. Corral—right next to Fly's Boardinghouse, where Earp crony and fellow gambler, Doc Holliday, was living. Had the cowboys gone there to ambush and kill Holliday?

Whatever their motives were for being where they were, it was while they were standing in that lot that the three Earps and Doc Holliday approached the cowboys. What happened next has been the stuff of myth and mystery ever since.

OVERLEAF:
PL. I. *Map of Tombstone, Arizona, 1880–1882*
Ink and colored pencil
18 x 36
Collection of the artist

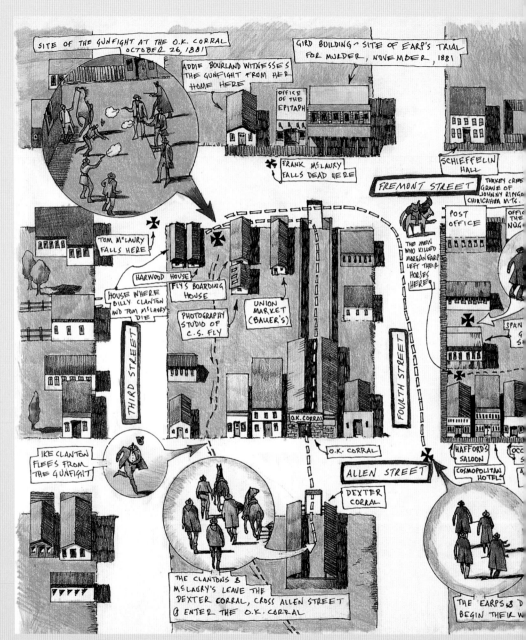

SITE OF THE GUNFIGHT AT THE O.K. CORRAL OCTOBER 26, 1881

GIRD BUILDING - SITE OF EARP'S TRIAL FOR MURDER, NOVEMBER, 1881

ADDIE BOURLAND WITNESSES THE GUNFIGHT FROM HER HOME HERE

OFFICE OF THE EPITAPH

FRANK McLAURY FALLS DEAD HERE

SCHIEFFELIN HALL

FREMONT STREET

TURKEY CREEK GRAVE OF JOHNNY RINGO CHIRICAHUA MTS.

POST OFFICE

OFFIC THE NUG

TOM McLAURY FALLS HERE

THE MEN WHO KILLED MORGAN EARP LEFT THEIR HORSES HERE

HARWOOD HOUSE

FLY'S BOARDING HOUSE

HOUSE WHERE BILLY CLANTON AND TOM McLAURY DIE

PHOTOGRAPHY STUDIO OF C.S. FLY

UNION MARKET (BAUER'S)

SPAN G S

THIRD STREET

FOURTH STREET

O.K. CORRAL

IKE CLANTON FLEES FROM THE GUNFIGHT

O.K. CORRAL

HAFFORD'S SALOON

OCC S

ALLEN STREET

COSMOPOLITAN HOTEL

A

DEXTER CORRAL

THE CLANTONS & McLAURY'S LEAVE THE DEXTER CORRAL, CROSS ALLEN STREET & ENTER THE O.K. CORRAL

THE EARPS & D BEGIN THEIR W

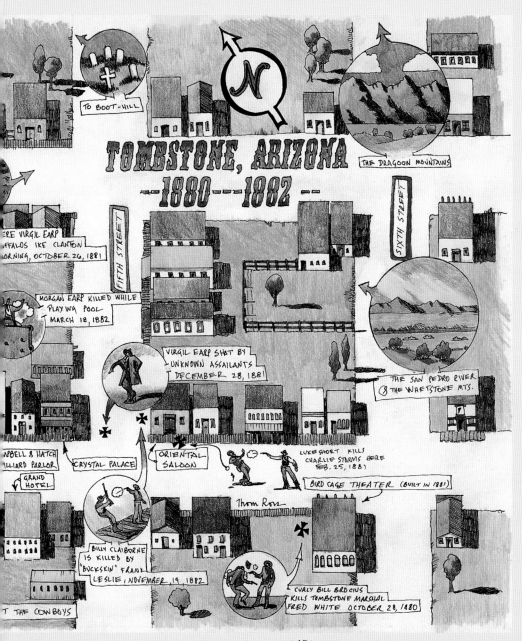

TO BOOT-HILL

THE DRAGOON MOUNTAINS

TOMBSTONE, ARIZONA
— 1880 — 1882 —

FIFTH STREET

SIXTH STREET

[H]ERE VIRGIL EARP
[BU]FFALOS IKE CLANTON
[M]ORNING, OCTOBER 26, 1881

MORGAN EARP KILLED WHILE
PLAYING POOL
MARCH 18, 1882

VIRGIL EARP SHOT BY
UNKNOWN ASSAILANTS
DECEMBER 28, 1881

THE SAN PEDRO RIVER
& THE WHETSTONE MTS.

[CA]MPBELL & HATCH
[B]ILLIARD PARLOR

CRYSTAL PALACE

ORIENTAL
SALOON

LUKE SHORT KILLS
CHARLIE STORMS HERE
FEB. 25, 1881

GRAND
HOTEL

Thom Ross

BIRD CAGE THEATER (BUILT IN 1881)

BILLY CLAIBORNE
IS KILLED BY
"BUCKSKIN" FRANK
LESLIE, NOVEMBER 14, 1882

CURLY BILL BROCIUS
KILLS TOMBSTONE MARSHAL
FRED WHITE OCTOBER 28, 1880

[A]T THE COWBOYS

When prospector, Ed Schieffelin, left Fort Huachuca in 1877 to explore the regions of southeast Arizona, sympathetic soldiers warned him that all he would find out there would be "his tombstone." Disregarding this warning, Schieffelin ventured forth into the San Pedro Valley and found a rich vein of silver. Recalling the soldiers' warning, he named his claim "Tombstone."

As word of his discovery spread, miners flocked to the area, and soon a small mining camp sprouted up on Goose Flats, with the camp taking on the name Schieffelin had called his first strike, "Tombstone." As with all frontier towns, the miners were followed shortly by townspeople, bartenders, renegades on the run, gamblers, and all the assorted riffraff one associates with any newly developing boom town. Cowboys, too, entered the area, searching for lands on which to graze their herds.

The cowboys had ready markets for their beef throughout the Southwest. Army forts, Indian reservations, and growing towns such as Tombstone all clamored for beef. One way to acquire cattle was to raise them; another way was to rustle them, and many cowboys became adept at this latter practice. They

The Cowboys

AFTER THE END of the Civil War, many displaced and destitute southerners headed west in search of new beginnings. Those who settled along the border between the southwestern United States and Mexico combined the traditional cowboy practice of raising and selling beef with the nefarious practice of cattle rustling. As these cowboys made their frequent forays into Mexico to steal cattle, tensions along the border escalated, until the thefts became a serious concern to the governments of both countries. Traditionally southern Democrats, the cowboys around Tombstone were in political conflict with the northern Republicans who populated the town and ran its businesses. While the town marshals, first Fred White and then Virgil Earp, were northern Republicans, the county sheriff, Johnny Behan, was a sympathetic Democrat and an ally of the cowboys, which created a major problem. An extreme outcome of this division was the killing of Frank Stilwell by Wyatt Earp. When Earp killed Stilwell, Stilwell was a deputy sheriff under Behan! In troubled social and political climates such as this, it was often hard to determine which side wore the white hats and which the black hats. Many still champion the case of the cowboys. In Tombstone today, overall sentiment leans toward the cowboys, with a more negative view of the Earps.

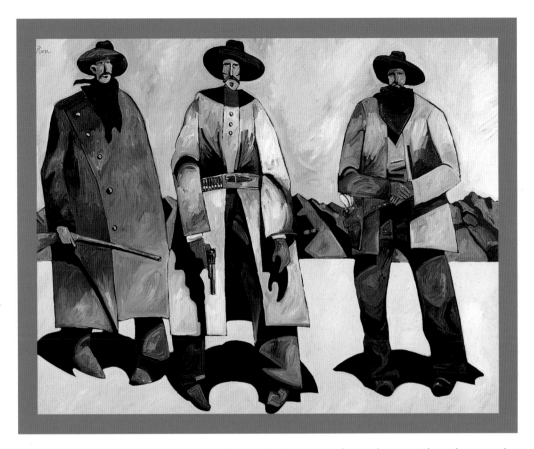

found it very lucrative to venture south into Mexico and steal cattle there, herding them back into Arizona to a ready and demanding market, governed by lawmen who would not ask questions or make a fuss over the ownership of the cattle.

Members of this cowboy/rustling organization included Johnny Ringo, "Curly" Bill Brocius, and Joseph Isaac "Ike" Clanton, who was the son of the man regarded as the leader of them all, Newton "Old Man" Clanton.

PL. 2. *Trio of Outlaws: Johnny Ringo, "Curly" Bill Brocius, Ike Clanton*
Acrylic on canvas
48 x 60
Private collection

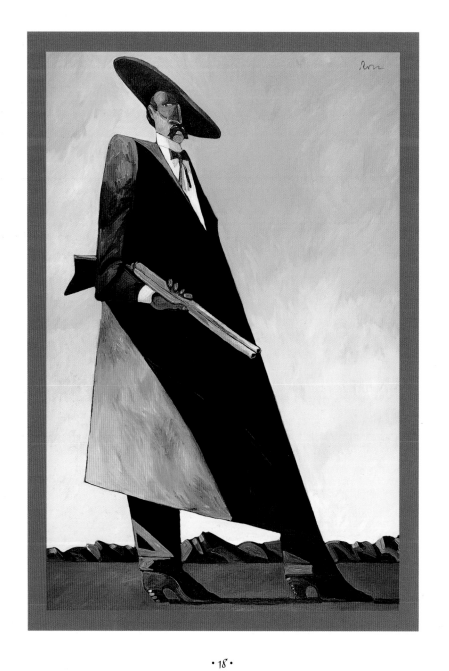

In December 1879, Wyatt Earp arrived in Tombstone, Arizona. With him was his common-law wife, Mattie. Also joining him were his brother, Virgil, who had picked up a commission as a Deputy United States Marshal, and his wife, Allie. They were joined later by two other brothers, James and Morgan. The brothers took on a variety of jobs, including gambling, bartending, law enforcement, and riding shotgun for Wells Fargo. In September 1880, the town of Tombstone "welcomed" another western character onto its wide-open streets in the form of John Henry "Doc" Holliday. A Georgian by birth, and a dentist by trade, Holliday had contracted tuberculosis and it was thought that the arid deserts of the West might prove beneficial. Due to his coughing and hacking from the illness, he was unable to make a steady living as a dentist, so he took up gambling as his main profession.

PL. 3. *Doc Holliday and the Dragoon Mountains*
Acrylic on canvas
60 x 40
Private collection

Doc Holliday

JOHN HENRY HOLLIDAY was born in Griffin, Georgia, in 1851. Raised in the genteel manner of a southern gentleman, Holliday graduated from the Pennsylvania College of Dental Surgery in 1872 and worked briefly out of an office in Atlanta. His persistent cough led doctors to conclude that Holliday had contracted tuberculosis, and they predicted the only chance of his survival was to seek the drier climate of the West. So out west he went. Once there, he was unable to build a successful practice since patients weren't enamored of a dentist who hacked, coughed, and spit up blood while working on their teeth. Holliday then turned his talents to gambling and built a reputation as a gambler, drifter, and alcoholic. In Dodge City, he met Wyatt Earp, and the two became friends. When the Earp clan settled in Tombstone, Arizona, Holliday joined them. His presence often proved an embarrassment to the Earps, but when they went to the O.K. Corral, it was Holliday who stood with them. Fleeing Arizona with Wyatt Earp in 1882, Holliday settled in Colorado, where his illness worsened. He moved to Glenwood Springs in the hopes that the hot sulfur baths there might improve his condition. They did not, and Holliday died there on the 8th of November, 1887. He was thirty-six.

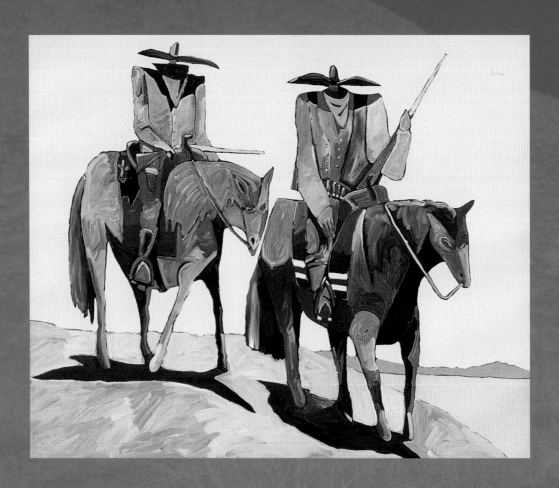

PL. 4. *Tom and Frank McLaury*
Acrylic on paper
30 x 38
Private collection

There were two distinct factions operating in Tombstone. One consisted of the townspeople, who were mostly businessmen and who were represented in the local law enforcement by Town Marshal Fred White. The other group was known as the "Cowboy" faction. These men included the ranchers and cowboys who lived and worked on the ranges surrounding Tombstone. Predominantly Democratic in their political persuasion, they had, as champion for their way of life, Cochise County Sheriff Johnny Behan. These two groups coexisted in an uneasy "understanding"—an "understanding" that would be sorely tested as events unfolded.

The rift between the two factions widened when six government mules were stolen in July 1880. Local talk placed the mules at the ranch of brothers Tom and Frank McLaury, on the Babocomari River just outside of Tombstone. In reward posters, Frank was even listed by name as one of the suspects. The Earps investigated the McLaurys' involvement with the stolen mules, and this added to the animosity between them. Later, in December of that year, Wyatt, whose horse had been stolen a few months before, finally found it in the town of Charleston, being ridden by Billy Clanton, the youngest of the Clanton brothers. Run-ins between these cowboys and the Earps would continue to grow, both in frequency and in hatred.

Virgil Earp was appointed assistant marshal for Tombstone, serving under Fred White. On the night of October 28, 1880, shots rang out in the streets of the town. Brothers Wyatt and Morgan ran out to investigate. They saw Fred White wrestling with a cowboy, and they ran over to help. As Wyatt grabbed the cowboy, White called out, "Now you goddamn son of a bitch, give up that pistol!" As he jerked the cowboy's gun, it went off and the bullet struck White just above his groin. Wyatt knocked the cowboy over the head with his pistol; he turned out to be "Curly" Bill Brocius. White lingered for a few days before dying of the wound. But before he died, he exonerated Brocius of any wrongdoing, claiming the shooting was accidental. Even Wyatt testified for Brocius at his trial. With White dead, Virgil Earp became town marshal of Tombstone, Arizona.

PL. 5. *"Curly" Bill Shooting the Moon*
Acrylic on canvas
36 x 36
Courtesy of the Kneeland Gallery

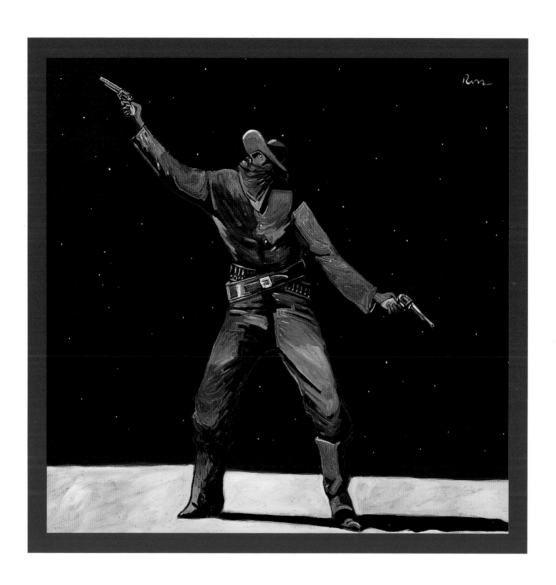

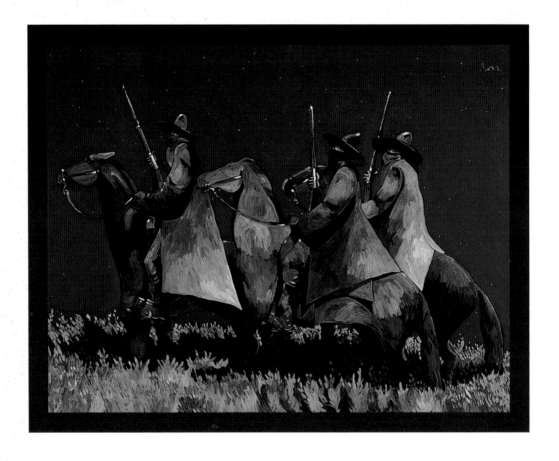

The robbing of stagecoaches in the West was a rare, but by no means uncommon, occurrence. In an effort to protect both the cargo and the passengers, most stagecoaches were manned with armed shotgun messengers. Tombstone had remained relatively free of this kind of crime until the night of March 15, 1881.

PL. 6. *The Benson Stage Robbers*
Acrylic on paper
30 x 38
Private collection

On that night, four masked men tried to rob the Benson–Bisbee stagecoach. The stagecoach was driven by Bud Philpot. Bob Paul was riding shotgun; the value of the silver shipment on board totaled close to $25,000. Leaving Tombstone and heading north, the coach passed through the small town of Contention. Shortly afterward, Philpot and Paul exchanged places, no one knows why, although Philpot had been complaining of stomach cramps.

PL. 7. *Four in the Road*
Acrylic on paper
24 x 32
Private collection

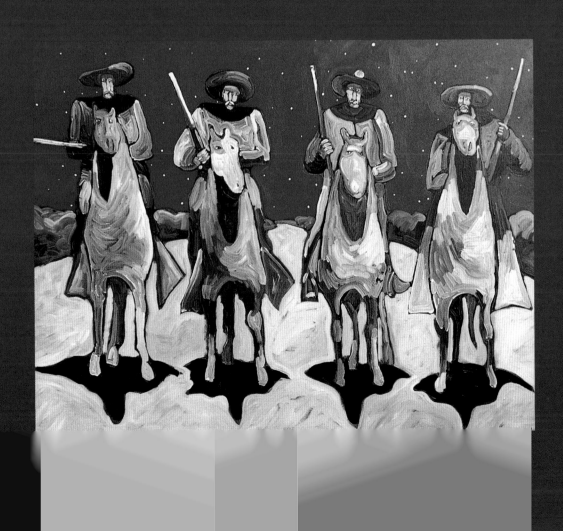

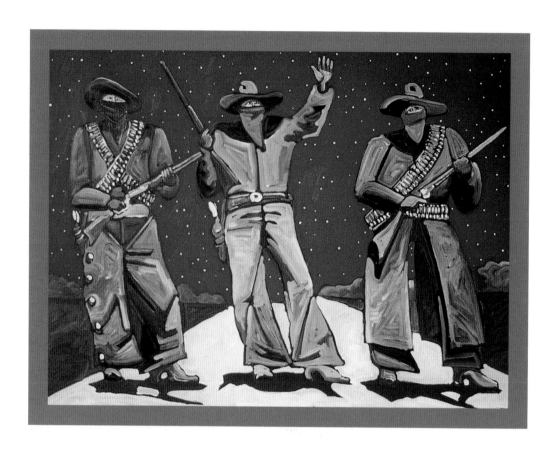

Suddenly a man appeared on the dark road ahead and called out the command, "HALT!" The man was soon joined by others. Then a shot was fired from the a gunman on the side of the road, fatally wounding Bud Philpot. As Philpot's body fell down to the road, Bob Paul was able to grab the reins and somehow return fire as the horses pulling the stage leapt into motion and raced past the startled bandits.

PL. **8.** *Three in the Road*
Acrylic on paper
24 x 32
Private collection

s the stagecoach flew past the failed robbers, they opened fire and killed a passenger, Peter Roerig, who was riding on the top of the coach. Paul was able to drive the coach to Benson, and when news of the robbery attempt hit the town of Tombstone, a large posse was quickly organized under the leadership of Johnny Behan. Included in the posse were Virgil, Wyatt, and Morgan Earp.

PL. 9. *Flight*
Acrylic on paper
24 x 32
Private collection

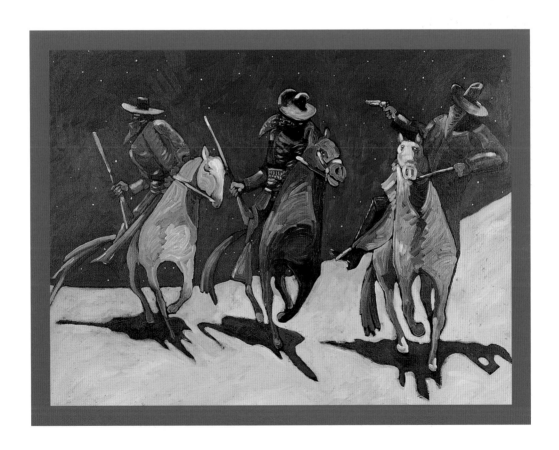

Following the trail left by the fleeing outlaws, the posse was able to capture one man, Luther King. He said he held the horses for the other three outlaws and named them as Harry Head, Billy Leonard, and Jim Crane. Escorted back to Tombstone, King walked into the jailhouse and right out the back door, no doubt with a slight nod of the head from Johnny Behan.

Frustrated by this occurrence, Wyatt Earp struck a deal with Ike Clanton: if Ike would turn over the four outlaws to Earp (to increase his political stature in his bid for the county sheriff's position), Wyatt would let Ike keep the reward money. Ike accepted the deal.

Then the deal began to backfire on Ike. Within weeks, three of the bandits—Crane, Head, and Leonard—were killed, and King had disappeared.

PL. 10. *Wyatt Earp at Midnight*
Acrylic on canvas
60 x 40
Private collection

 ## The Demise of the Benson Stage Robbers

OF THE FOUR MEN who tried to rob the Benson stagecoach in March 1881, three met violent deaths shortly after the failed robbery attempt. Harry Head and Billy Leonard rode into New Mexico and were promptly slain by the Hazlett brothers. Why the brothers killed the two men is not known. Some say the Hazletts killed them for the reward offered by Wells Fargo. Others think that the Hazletts suspected them of being hired guns who were coming to oust the brothers from their ranch. Whatever the reasons, the secret died with the Hazlett brothers as they were, in turn, killed by a group of rustlers headed by yet another of the four Benson robbers, Jim Crane. Crane would die in an ambush at Guadalupe Canyon a few months later. Only one of the Benson stage robbers, Luther King, seems to have survived, and no one is sure what became of him.

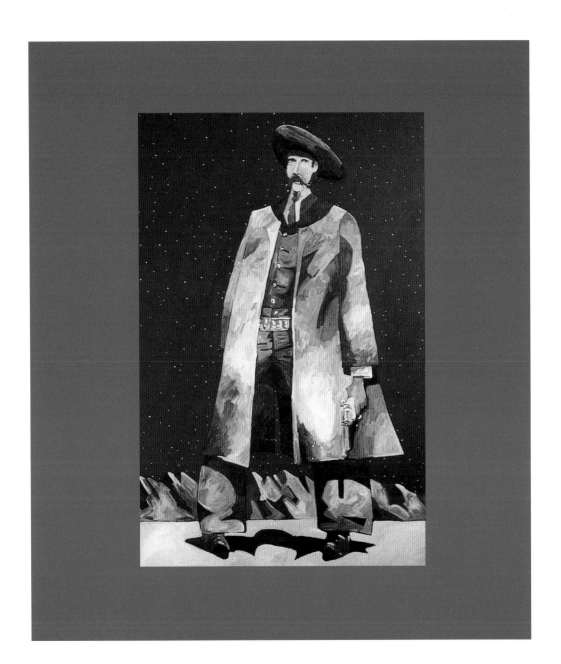

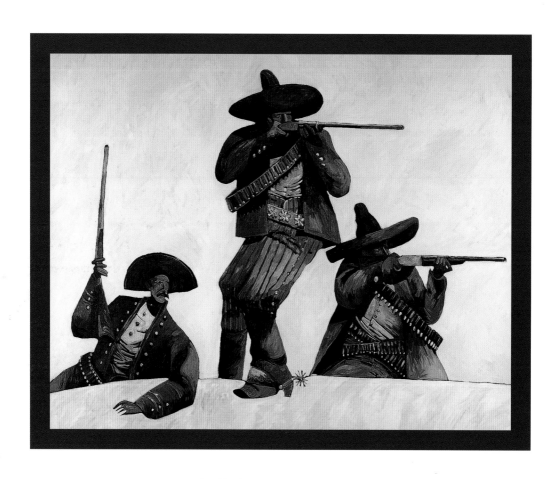

PL. II. *Guadalupe Canyon Massacre*
Acrylic on canvas
48 x 60
Private collection

In early August 1881, a group of Mexicans on horseback escorting a mule train was ambushed in aptly named Skeleton Canyon. The canyon lies in southeast Arizona, just over the Mexican border. Whether these Mexicans were smuggling silver out of the states or were returning from a mining expedition is unclear. However, the reason for the ambush is very clear: the mule train was thought to be laden with silver. The attackers were members of the "Cowboy" faction; Wyatt Earp was "satisfied" that the McLaury brothers were involved. Soon after the ambush, the town of Galeyville, which was a notorious hangout for the cowboys, was flooded with Mexican coins, silver bullion, and mescal!

Then on August 15, probably in retaliation for the Skeleton Canyon ambush, a Mexican patrol came upon seven Americans camped in Guadalupe Canyon, located in Arizona, not far from Skeleton Canyon. At dawn the Mexicans opened fire, killing five of the men, including "Old Man" Clanton and the last of the Benson stage robbers, Jim Crane.

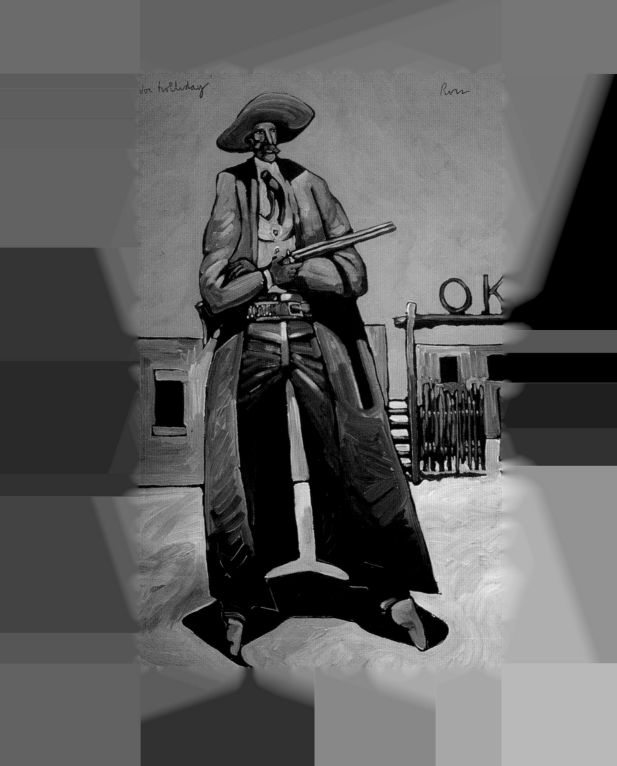

With the death of the last Benson stage robbery suspect, Ike Clanton began to grow uneasy about the deal he had made with Earp. As long as the robbers were alive, it was in the best interests of both Ike Clanton and Wyatt Earp to keep silent about their deal. Now, with the robbers out of the picture, Ike began to fear that Wyatt might let it be known that Clanton had been ready to sell out his fellow cowboys for a reward. If word of Ike's deal got back to "Curly" Bill and the other cowboys, Ike's life would be in grave danger.

In a poor effort to turn attention away from himself, Ike Clanton began to proclaim that Doc Holliday had been involved in the robbery attempt! Even Sheriff Johnny Behan lent Clanton a hand. He got Doc's girlfriend, "Big Nose" Kate Elder, drunk and had her sign a statement that implicated Doc in the robbery. When she sobered up, she recanted, but Doc's anger toward Ike Clanton was not as easily withdrawn. (Doc defended his innocence by saying, "If I had been in on the job, I would have gotten the money!")

On the night of October 25, 1881, Doc came upon Ike in the Alhambra Saloon and began to threaten him. Ike argued back. Doc told Ike to get a gun and get to fighting. Morgan Earp walked up and took the two men outside. They were followed closely by Virgil Earp, who told the two men that he would arrest them if they didn't stop the squabbling.

Wyatt Earp then stepped in and took Holliday down the street, walking him to the boardinghouse where he was staying.

PL. 12. *Doc Holliday*
Acrylic on paper
24 x 15
Private collection

Ike returned to the saloon and, joined by Tom McLaury, who had ridden into Tombstone with Ike that same morning, the two entered into an all-night poker game. Also sitting in on the game were Johnny Behan and Virgil Earp.

Ike continued to drink heavily and began to complain that the pistol that Virgil had in plain view on his lap was making him nervous. Shortly before dawn, the game broke up.

As Virgil stepped outside, Ike accosted him and asked him to take a message to Doc Holliday. The gist of the message was: "The damned son of a bitch has got to fight!" Virgil refused to take the message to Holliday and suggested that Ike go sleep it off somewhere. As he turned to walk home, Ike yelled after him, "You may have a fight before you know it!" Virgil ignored the drunkard and headed home to bed. It was now the morning of October 26, 1881.

PL. 13. *The Poker Game*
Acrylic on paper
24 x 24
Private collection

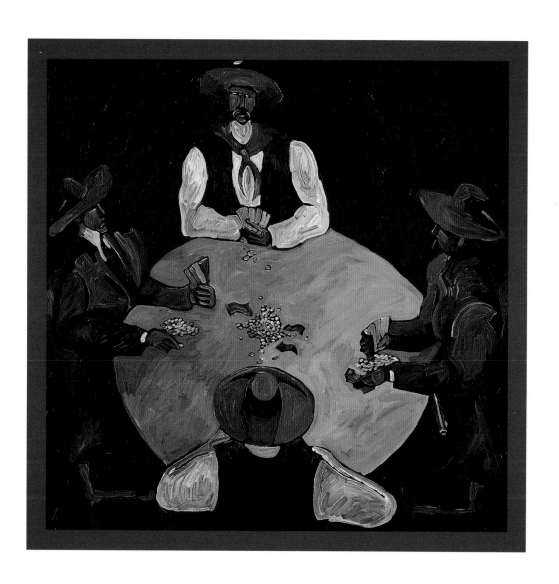

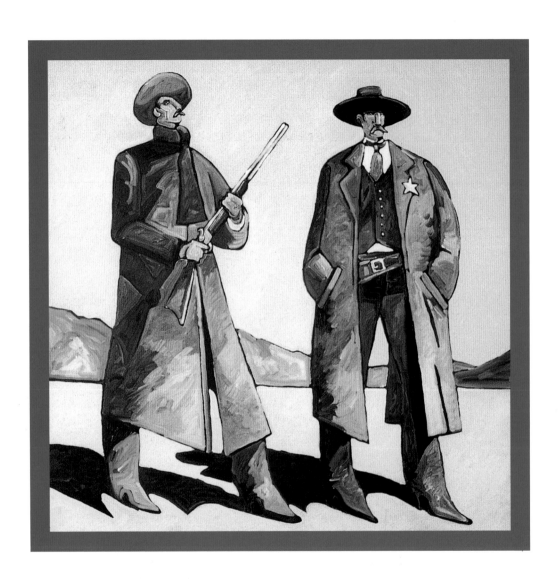

Around nine in the morning, a local citizen woke Wyatt Earp and informed him that Ike Clanton was still going around town making threats toward the Earps. He quoted Ike as saying, "As soon as those damned Earps make their appearance on the street today, the ball will open! We are here to make a fight. We are looking for the sons of bitches!" Told that Ike was now armed with a rifle and pistol, Wyatt got up and went down to the Oriental Saloon.

A very sleepy Virgil Earp was also informed of Ike's threats. His deputy, Andy Bronk, told him, "You had better get up. There is liable to be hell. Ike Clanton has threatened to kill Holliday as soon as he gets up. He's counting you fellows in too!"

Virgil, hoping the situation would blow over, went back to bed.

PL. 14. *Doc & Wyatt*
Acrylic on canvas
36 x 36
Private collection

The Earp Brothers

A CLAN OF BROTHERS from the Midwest, the Earps achieved enormous popularity early in the twentieth century, due largely to the writings of Walter Noble Burns and Stuart Lake. The oldest brother, Newton Earp (1837–1928), was a half-brother to his more famous siblings: James C. Earp (1841–1926), Virgil Walter Earp (1843–1906), Wyatt Berry Stapp Earp (1848–1929), Morgan Earp (1851–1882), and Warren Earp (1855–1900). Moving back and forth across the western landscape, the brothers took on a variety of jobs common to the frontier: gambling, saloon-keeping, mining, and law enforcement.

Wyatt seems to have been the most dominant of the brothers in personality, although historians credit Virgil with being the best lawman. James, wounded in the Civil War, never participated in his brothers' work as lawmen, preferring instead to work as a saloon-keeper/bartender. Virgil, Wyatt, and Morgan became the famous "Fighting Earps" or, as some of their enemies called them, the "Fighting Pimps."

Warren was killed in a bar fight in 1900. Some think his death was due to the Tombstone troubles of twenty years before. Some even claim that Virgil hunted down and killed the

man he thought was responsible for Warren's death. Virgil wandered the West with his wife, Allie, and died in Goldfield, Nevada, in 1906 from pneumonia. James and Newton lived well into the twentieth century, but apparently never held much interest for historians. The same could not be said of Wyatt. In the late 1920s, his story, especially the Tombstone saga, was elevated to mythic proportions by Walter Noble Burns' *Tombstone: An Iliad of the Southwest* (1927) and later Stuart Lake's *Wyatt Earp: Frontier Marshal* (1931). Historians have been searching for the truth ever since.

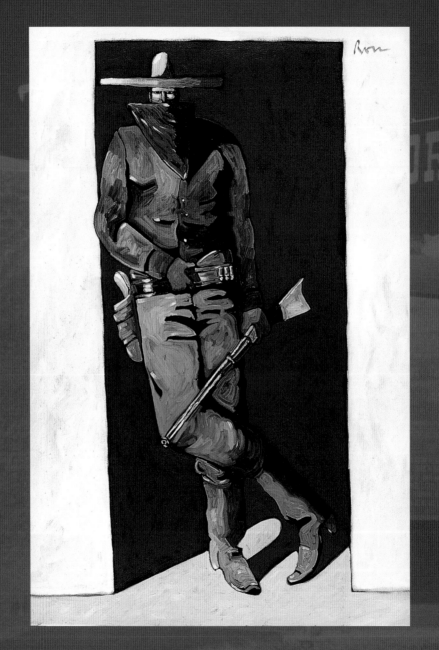

As these events were unfolding in Tombstone, Ike Clanton's younger brother, Billy, and Tom McLaury's older brother, Frank, were finishing their breakfast at the Chandler Milk Ranch, located a few miles outside of Tombstone. The two men had spent the night out on the range and, as day broke, they finished their meal and saddled up their horses to begin a leisurely ride toward Tombstone.

PL. 15. *Dawn: Cowboy in the Doorway*
Acrylic on canvas
36 x 24
Private collection

Virgil had no luck going back to sleep. A constant stream of visitors, each one informing him of some new threat by Ike Clanton, kept waking him. He finally got up and went into town, where he found Wyatt. Together, the two men hunted the streets, looking for Ike. Virgil found him and, walking up behind him, struck the bleary-eyed drunk over the head with the barrel of his gun. Clanton collapsed to the ground in a heap.

Wyatt and Virgil hauled Ike over to the courthouse. While Virgil went in search of the judge who would impose a sentence on Ike, Morgan Earp entered the courtroom. Ike and Morgan picked up where Ike and Doc Holliday had left off the night before! Finally Virgil and the judge arrived at the courthouse and Ike was fined $27.50.

All parties then left the courthouse. As Wyatt walked out the door, he bumped into Tom McLaury. Tom, a pistol on his hip, threatened Wyatt, saying, "If you want to make a fight, I will make a fight with you anywhere." Wyatt slapped Tom's face and, drawing his own pistol, smacked Tom on the side of the head with it, sending him tumbling to the ground.

It was about this time that Frank McLaury and Billy Clanton rode into Tombstone. They were soon informed of what had been going on that morning. Sensing trouble, neither man checked in his gun as the local law required. Walking up the street, they met up with Tom and Ike. As a group, they entered Spangenberg's gun shop.

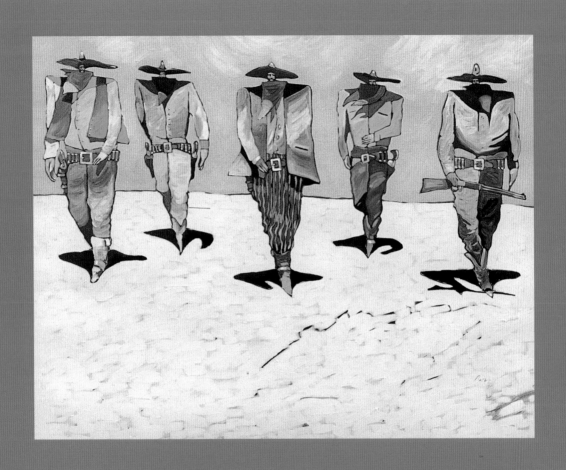

PL. 16. *Men from the Babocomari*
Acrylic on paper
30 x 38
Private collection

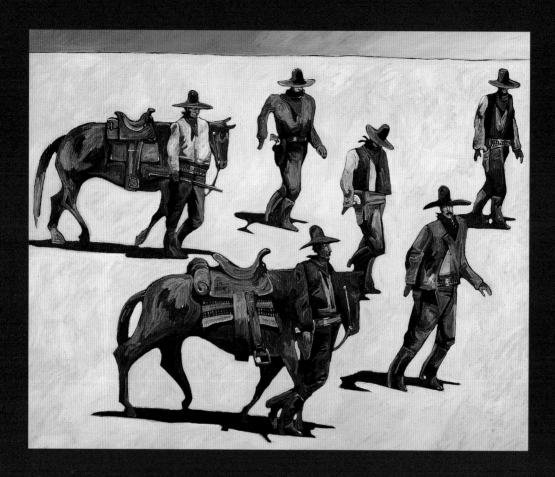

PL. 17. *Crossing Allen Street*
Acrylic on canvas
48 x 60
Private collection

Frank McLaury's horse added to the morning's tension when it slowly stepped up onto the boardwalk in front of the gun shop. Because there was a city ordinance against horses being on boardwalks, Wyatt Earp strode over and yanked the animal back onto the street. Frank, seeing this, ran out the door of the gun shop and confronted Wyatt, telling him to keep his hands off his horse. Wyatt informed Frank of the infraction, then turned and walked away.

While this was taking place, Virgil, seeing the gathering of cowboys, walked over to the Wells Fargo office and borrowed one of the company's shotguns.

The cowboys then walked over to the Dexter Corral and grabbed Billy Clanton's horse. The four men were joined by another cowboy, Billy Claiborne, and together they crossed Allen Street and entered the O.K. Corral.

The cowboys passed through the O.K. Corral and exited the rear entrance onto Fremont Street. Turning left, they entered a small vacant lot next door to both Fly's Photo Studio and his boardinghouse, where Doc Holliday was living. There has always been some suggestion that the cowboys might have gone there hoping to ambush Doc. If such were their intentions, they were out of luck. Doc was already up and, by this time, had joined the Earps a few blocks away.

Thinking the cowboys were still inside the O.K. Corral, Virgil knew he had no authority to arrest the armed men: the law allowed men to be armed inside a corral if they were either just entering town or getting ready to leave. Virgil and Johnny Behan then entered Hafford's Saloon. Behan ordered a drink. Virgil asked for Behan's help in the event he needed to make an arrest. Behan refused. Two men then came up to Virgil and offered their assistance in the event of trouble. Virgil informed the two men that as long as the cowboys remained inside the corral, he would not approach them. However, if they ventured out onto the street, he would be obliged to arrest them. Behan then volunteered to go see if he could talk to the cowboys and calm the situation.

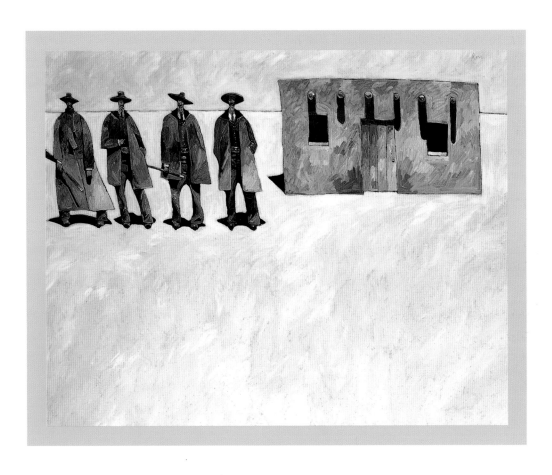

PL. 18. *The Calm Before the Storm*
Acrylic on canvas
48 x 60
Private collection

It was then that Virgil was informed that the cowboys had left the confines of the O.K. Corral and were loitering in the streets. Here was the excuse Virgil needed to arrest the renegades. Virgil walked out of Hafford's and saw Wyatt with Morgan and Doc standing in the middle of Allen and Fourth Street, with a large crowd gathered around them.

Virgil now became concerned about the shotgun he had taken from the Wells Fargo office. As he stated later, "I did not want to create any excitement by going down the street with a shotgun in my hand." Instead of carrying the deadly weapon himself, he handed it to Holliday and told him to hide it in the skirts of his long coat. Doc passed his walking cane to Virgil, took the shotgun, and tucked it inside his coat.

Guns of the O.K. Corral

WHEN THE EARPS met the Clantons at the O.K. Corral, bullets flew. But where did the bullets come from? The three Earp brothers each carried a pistol. Virgil's was in a holster, which he had pushed around toward the back of his left hip. Wyatt's pistol was held in his hand in his coat pocket. (This was probably not the celebrated "Buntline Special," though one man at the trial stated that the gun in Wyatt's hand appeared to him as "pretty large, 14 or 16 inches long, it seemed to me.") How Morgan carried his gun is unknown. Doc Holliday likewise had a pistol on his person which, during the court hearing, was described by witnesses as being "nickle-plated." The shotgun given him by Virgil shortly before the gunfight was described as a "short shotgun, such as is carried by Wells Fargo & Co. messengers." The whereabouts of any of these guns remains a mystery.

Of the cowboys, only Frank McLaury and Billy Clanton are known to have been armed. They had just ridden into town and had not yet turned in their guns, as was required by town law. Having heard of the altercations that took place earlier that morning between the Earps and Ike Clanton and Tom McLaury, the two men undoubtedly kept their guns in anticipation of trouble. Both guns were Colt .44—.40 Frontier six-shooters. Frank's gun had serial number 46338, and Billy's was serial number 52196. Both guns would be of great value today.

The question of whether Tom McLaury was armed has never been satisfactorily answered. On a map of the gunfight he drew years later, Wyatt Earp carefully denoted a spot where "Wesley Fuller picked up Tom McLowery's [sic] gun from body at 3rd and Fremont Street." As with the guns of the Earps, none of the cowboys' weapons have ever surfaced. The shotgun Wyatt Earp used to kill "Curly" Bill Brocius has been identified and is in the hands of a private collector.

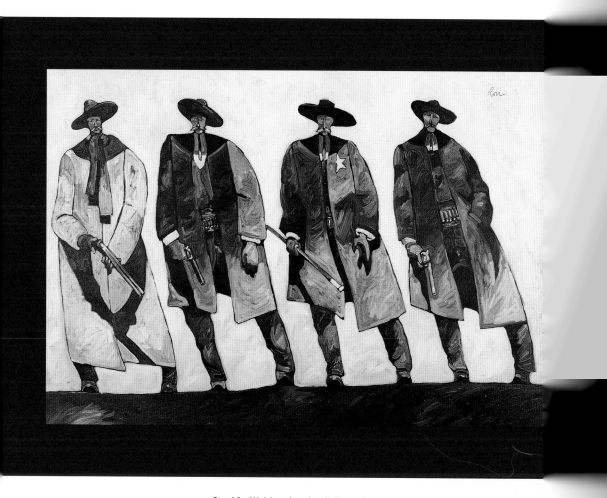

PL. 19. *Waiting for the Ball to Open*
Acrylic on canvas
40 x 60
Private collection

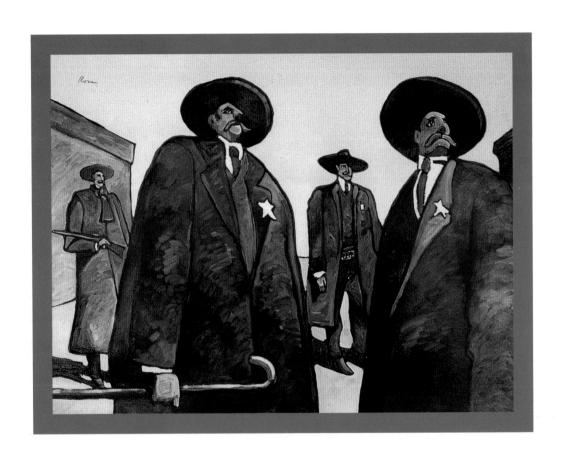

PL. 20. *The Decision*
Acrylic on paper
30 x 38
Private collection

Virgil then decided to try to arrest the cowboys. With Doc's cane in his hand and his pistol holstered behind him on his left hip, Virgil turned to his brothers and Doc Holliday and merely muttered, "Come along."

The O.K. Corral Gunfight, Hollywood-Style

FILM BUFFS HAVE claimed that the Gunfight at the O.K. Corral has been the subject of more film Westerns than any other single event from the Old West. While many of these films were obviously inspired by the actual gunfight, the name of the town, the gunfight site, and even the participants are often changed and, in the desire to tell a good story, the known facts of the gunfight are often overlooked or ignored altogether.

The most recent contributions to the cinematic retelling of the story have claimed authenticity, but all seem to fail in this department to a greater or lesser degree. I agree with film critics who praise John Ford's interpretation of the story in *My Darling Clementine* (1946). While his film captures the mythical essence of Wyatt Earp and the gunfight, Ford gets almost everything historically wrong.

Tombstone (1993) is the best-looking reconstruction of the event in terms of costume, dialogue, cowboy rigs of the era, the names of the people involved, and the look of the town. The gunfight itself is often shown as the end-all grand finale that uninformed viewers expect it to have been. Recent movies such as *Tombstone* and *Wyatt Earp* (1994) have correctly placed it in its proper position as just one of many events in a long and sordid tale. Even the duration of the fight is slowly getting closer to its historically accurate length of approximately thirty seconds. In *Gunfight at the O.K. Corral* (1957), the gunfight lasts more than seven minutes, while in *Wyatt Earp* it comes in at just under forty-five seconds.

Walking two abreast down Fourth Street, the Earp/Holliday quartet began their famous journey into history and legend. Virgil and Wyatt took the lead, Doc and Morgan followed.

The Gunfight Site

THE FAMOUS GUNFIGHT at the O.K. Corral did not take place in the corral, but rather in a vacant lot down the street from the corral's rear entrance. It is still possible today to "walk the walk" and follow in the footsteps of the Earps and Doc Holliday, starting from where Hafford's Saloon stood (Fourth and Allen Streets), down Fourth to Fremont Street, then left on Fremont. You will pass the rear entrance to the O.K. Corral on your left: soon you will come to the place where Virgil and his men confronted the cowboys. Unfortunately this is marked by a tall adobe wall, which blocks your entrance to the gunfight site. To view the site itself, you have to enter by the front way on Allen Street, close to the manner in which the cowboys entered and walked through the fabled corral. After paying your money to enter, you are soon confronted by some pretty bizarre mannequins, placed randomly around the yard to suggest the positions of the nine men. The lot itself is much wider today than it was in 1881 when the gunfight occurred. This is because the Harwood house, which the cowboys had at their backs, is missing, thus creating much more space than the participants actually had. The placement of the fiberglass figures in the corral is conjectural and should be dismissed by serious students of the fight.

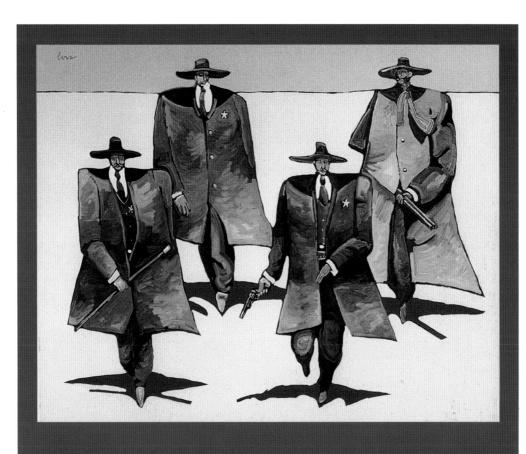

PL. 21. *Down Fourth Street*
Acrylic on paper
30 x 38
Private collection

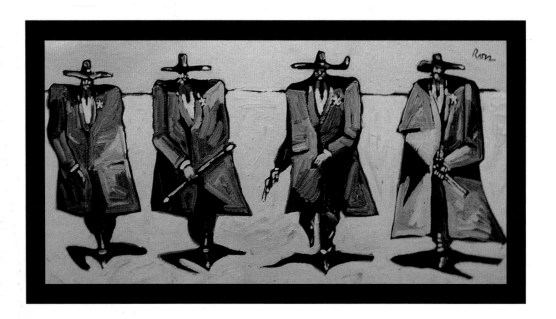

At the intersection of Fourth and Fremont, the Earp party turned left. Walking down Fremont Street, the quartet passed by the rear entrance to the O.K. Corral. Up ahead they could see some of the cowboys; the others were hidden from view in the back of the lot.

PL. 22. *Down Fremont Street*
Acrylic on paper
30 x 38
Private collection

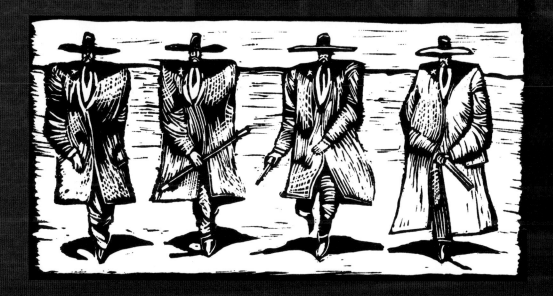

PL. 23. *Morgan, Virgil, Wyatt, and Doc*
Linoleum block print
6 x 12
Collection of the artist

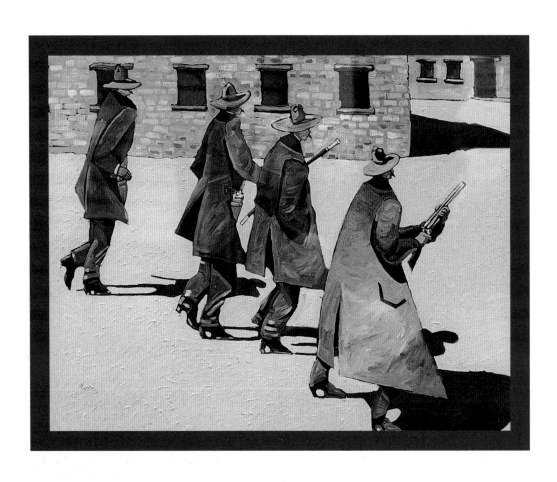

PL. 24. *They Walked Past Me Down the Street*
Acrylic on paper
30 x 38
Private collection

After passing the rear entrance to the O.K. Corral, the Earps walked past Bauer's Butcher Shop. Inside the shop someone said, "There they come!" According to the testimony that she gave at the trial after the shooting, Martha King, who was shopping there at the time, walked to the doorway and identified Holliday, whom she knew, as he strolled past her. However, she did not know the other three men walking with him. She claimed that she heard the man walking next to Holliday (probably Morgan Earp) say, "Let them have it," and she heard Holliday reply, "All right."

The Trial

WITHIN DAYS OF the gunfight, Ike Clanton filed murder charges against the Earps and Doc Holliday. Judge Wells Spicer then held a hearing to determine if the Earps and Holliday should be put on trial for murder. After the two-day hearing, warrants were issued for the arrests of Doc Holliday, Virgil, Wyatt, and Morgan Earp, on the charge of triple-murder. In early November, the McLaurys' other brother, Will, arrived in Tombstone. Recently widowed, Will left his law practice and his children in Fort Worth, Texas. He settled in Tombstone and joined the prosecution team. In a letter that he wrote to his law partner in Texas, McLaury expressed his expectations for the outcome of the trial when he wrote simply, "I think we can hang them." His prediction was premature.

Because both were still recovering from wounds sustained in the gunfight, Morgan and Virgil Earp did not appear at trial. Wyatt was allowed to read from a prepared statement in which he told his version of the events leading up to the gunfight. Numerous witnesses were called upon to testify, but neither side could develop a consistent story line to back up its claims.

When the trial ended, the Earps and Doc Holliday were acquitted; however, the repercussions of the gunfight would last far longer. Frustrated by the outcome of the trial, Will McLaury vowed revenge.

Some historians believe that Will may even have participated in the shootings of Virgil and/or Morgan Earp. Records of the trial can be found in Douglas D. Martin's *Tombstone's Epitaph* (1951) and in Alford E. Turner's *The O.K. Corral Inquest* (1981). Will McLaury's letters are archived at the New York Historical Society in New York City.

In the lot were six men: Tom and Frank McLaury, Ike and Billy Clanton, Johnny Behan, and Billy Claiborne, the latter of whom assured Behan he was not there to cause trouble but was only talking with his friend, Billy Clanton. Joining them now was another friend of Clanton's, Wes Fuller, who had come down to warn Billy of the Earps' deadly intent. Behan left the group when he saw the approach of the Earps.

Of the six cowboys now in the lot, two—Billy Clanton and Frank McLaury—are known to have been armed. They had just ridden in off the range and had not yet turned in their guns.

The question that has confounded historians ever since that day is whether Tom McLaury was armed. When he bumped into Wyatt Earp earlier in the day, some witnesses claimed he had a pistol on his hip. He was then seen going into the Capitol Saloon, where he turned this gun in to the owner, Andy Mehan. The only other scenario that could exist to explain Tom's entering the Capitol Saloon was that he was unarmed when he bumped into Wyatt Earp and that he went to the saloon to retrieve his gun from behind the bar. If such was the case, he might then have had it at the O.K. Corral fight. When he was seen on the streets earlier that morning, his shirt had been tucked into his trousers. Yet when he emerged from Spangenberg's gun shop with the other cowboys, his shirt was, for some reason, pulled outside his trousers and was seen hanging over his waist. Was he hiding a gun in his pants or in his belt? Had his brother slipped him a gun in anticipation of a fight?

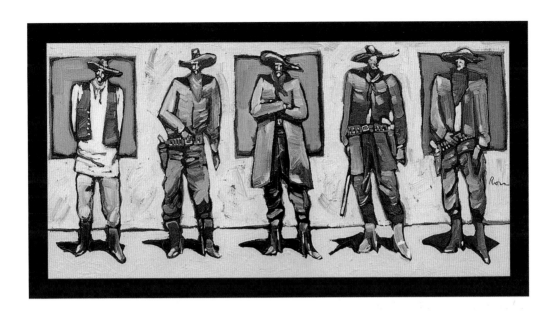

PL. 25. *Waiting in the Corral*
Acrylic on paper
14 x 22
Private collection

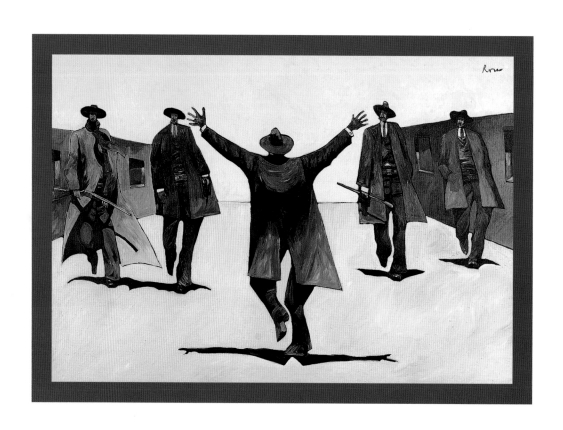

PL. 26. *Don't Go Down There!*
Acrylic on canvas
40 x 60
Courtesy of the Wilde—Meyer Gallery

As the Earps drew nearer, Johnny Behan confronted them. He made a feeble effort to stop the Earps, commanding them not to continue. Accounts vary as to what was actually said. According to Behan's testimony later, he said, "Gentlemen, I am sheriff of this county, and I am not going to allow trouble, if I can help it." Wyatt Earp remembered Behan saying simply, "For God's sake, don't go down there or you will get murdered."

Virgil then spoke, telling Behan, "I am going to disarm them," and the four men swept past the sheriff. Regardless of whose testimony you believe, Behan's efforts to diffuse the volatile situation were, at best, poor. Behan fell in behind the Earps and, when they entered the lot, he ran through the lot, grabbing Billy Claiborne and huddling with him in between Fly's Boardinghouse and photo studio.

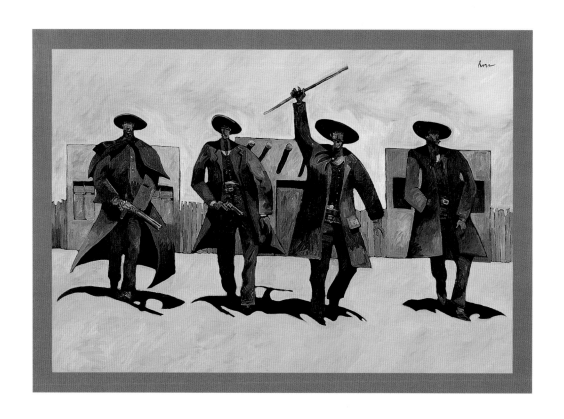

PL. 27. *Boys, Throw Up Your Hands!*
Acrylic on canvas
40 x 60
Private collection

As the Earps came closer to the cowboys, it was obvious to them that at least two of the cowboys were armed. Billy Clanton and Frank McLaury had pistols on their hips. (Billy's was on his left hip in a "butt-forward" position for a "reverse" draw.) Virgil Earp entered the lot and called out to the cowboys, "Boys! Throw up your hands! I want your guns!"

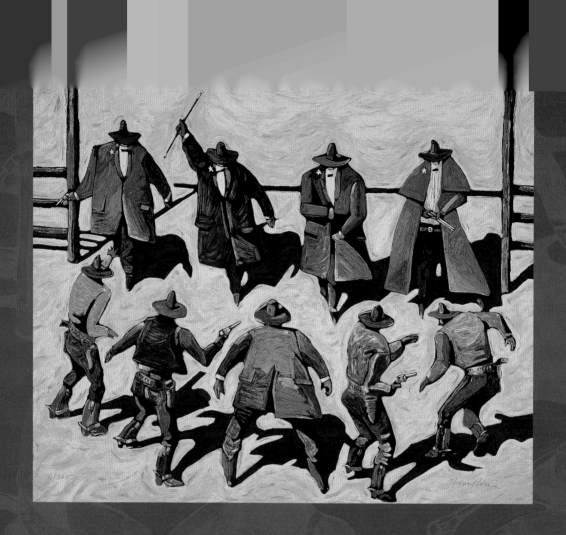

Pl. 28. *Gunfight at the O.K. Corral*
Limited edition serigraph
Signed and numbered
30 x 38

Top row, left to right: Morgan Earp, Virgil Earp, Wyatt Earp, Doc Holliday.

Bottom row, left to right: Billy Claiborne, Tom McLaury, Ike Clanton, Billy Clanton, Frank McLaury.

What actually happened in the next thirty seconds has been debated and argued about ever since that fateful October day in 1881. Some claim the cowboys did indeed throw up their hands in surrender, Tom McLaury calling out, "I haven't got anything. Boys, I am disarmed." And some reported that Billy Clanton put his hands out in front of himself and yelled, "Don't shoot me. I don't want to fight!"

Wyatt Earp, in testimony given at the trial following the gunfight, recalled those opening moments differently. He testified that he saw Billy Clanton and Frank McLaury go for their guns. Virgil, encumbered by the cane in his hand, fumbled for his revolver, which was in its holster toward the back of his left hip. Wyatt was much quicker and yanked his pistol from where he had placed it in his coat pocket. According to Wyatt's testimony, "The first two shots were fired by Billy Clanton and myself, he shooting at me and I shooting at Frank McLaury. I don't know which was fired first. We fired almost together."

So it was that Billy Clanton and Wyatt Earp opened fire, the pair of shots sounding as one; the gunfight in the vacant lot just down the street from the O.K. Corral was on!

PL. 29. *Billy Clanton*
Acrylic on canvas
60 x 48
Courtesy of the Wilde—Meyer Gallery

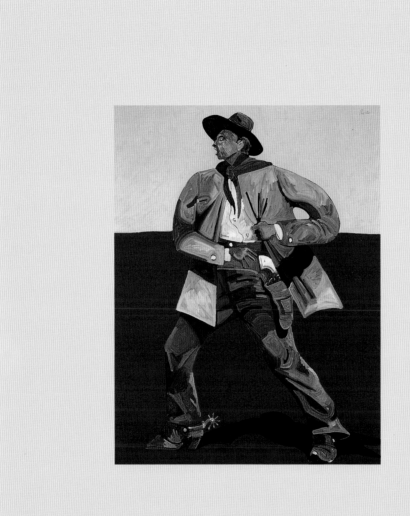

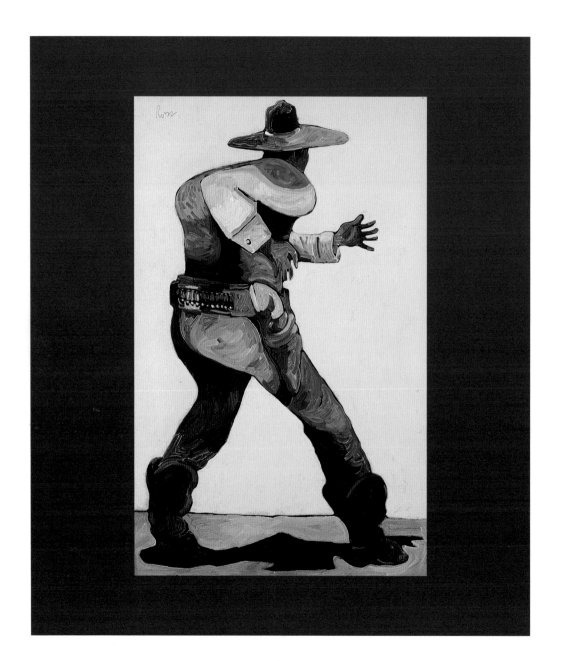

The actual placement of the figures involved in the gunfight has, like so many of the facts of the showdown, been a source of conjecture and contention. Best accounts place the men like this: As you looked into the vacant lot, on your left, and deepest in the lot, was Virgil Earp. The next man toward you would have been Wyatt, then Morgan, standing on or near the boardwalk, and, finally, standing in the street itself, was Doc Holliday.

The cowboys would be on the right and arranged more or less as such: Deepest in the lot was Billy Clanton. Next to him and on his left, would be Ike Clanton. Two ponies stood at the corner of the lot and the street and, when the fighting broke out, Tom McLaury jumped behind them. In front of the ponies and near the street, stood Frank McLaury. (Claiborne and Behan had already fled from the lot and Wes Fuller made his exit too, claiming to have backed out the rear of the lot, and thus, he said, he was able to witness the fight.)

PL. 30. *Frank McLaury Went for His Gun*
Acrylic on canvas
36 x 24
Private collection

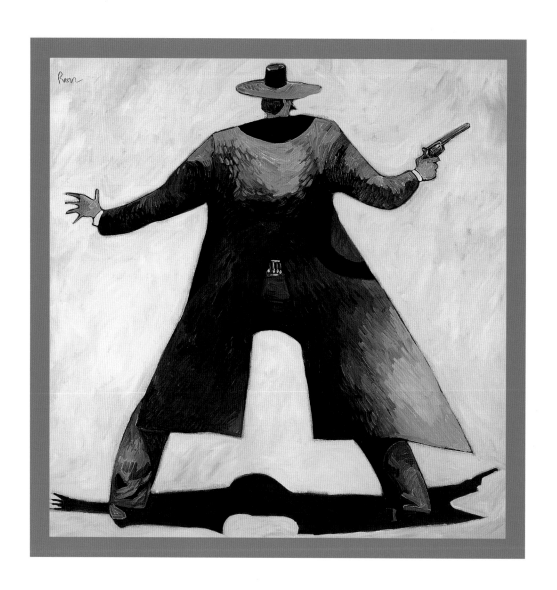

Billy Clanton's first shot flew wide of Wyatt. Wyatt's shot, however, found its mark, striking Frank McLaury in the belly. Witnesses and participants noticed a sudden lull in the activity, as if everyone were stunned by the sudden eruption of violence. In that moment, Ike Clanton ran up to Wyatt and grabbed him by the arm, the jolt causing Earp's gun to go off, sending a bullet harmlessly into the ground. As Ike begged for his life, Wyatt yelled at him, "This fight has commenced! Get to fighting or get out!" Ike wisely got out, dashing into Fly's Boardinghouse.

With Ike gone, Morgan now had a clear shot at Billy Clanton. Firing his gun, Morgan's bullet struck the eighteen-year-old Clanton in the chest. The impact of the shot knocked Billy back against the wall of the Harwood house.

PL. 31. *Wyatt Earp in Action*
Acrylic on canvas
36 x 36
Private collection

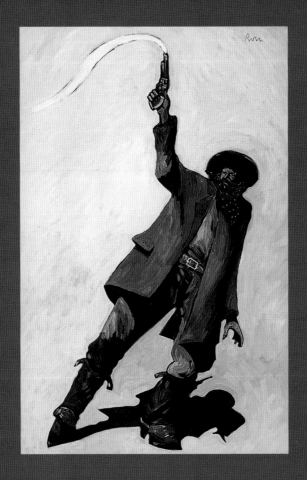

Frank McLaury, with Wyatt's bullet lodged in his stomach, fired a shot that struck Virgil Earp in the calf, knocking the lawman to the ground. Virgil, his gun now in hand, rose up quickly and commenced shooting. Frank was seen staggering from the lot out onto the street.

PL. 32. *Frank McLaury*
Acrylic on paper
27 x 17
Courtesy of the Wilde—Meyer Gallery

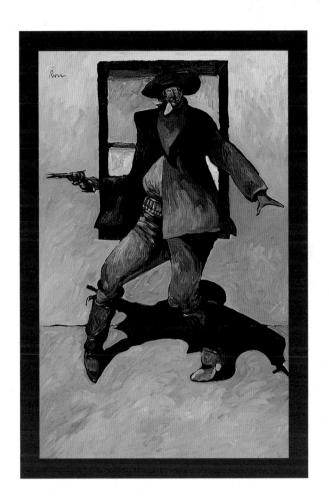

Tom McLaury had jumped behind one of the ponies, possibly in an attempt to use it as a shield or to grab a Winchester from its scabbard.

PL. 33. *Tom McLaury*
Acrylic on paper
27 x 17
Private collection

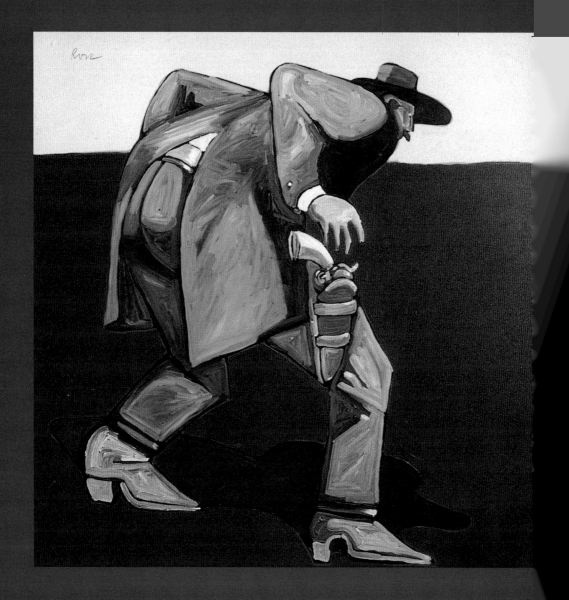

Suddenly one of the cowboys shot Morgan Earp. Whoever the shooter was sent a bullet that struck Morgan in the right shoulder. It passed along his back, chipping his spine, and exited out the left shoulder. Morgan fell to the ground.

PL. 34. *Gunfighter in Red: Morgan Earp*
Acrylic on paper
20 x 20
Private collection

At their trial following the gunfight, both Virgil and Wyatt testified that they thought Tom McLaury was armed. Seeing him hidden behind one of the ponies, Wyatt knew he would be a hard man to hit with a bullet. To force Tom out into the open, Wyatt took a shot at the withers of the pony behind which Tom was hiding. Stung by the shot, the pony lurched out of the lot, thus exposing Tom to the gunfire of the Earps.

PL. 35. *The Purple Horse*
Acrylic on canvas
48 x 54
Private collection

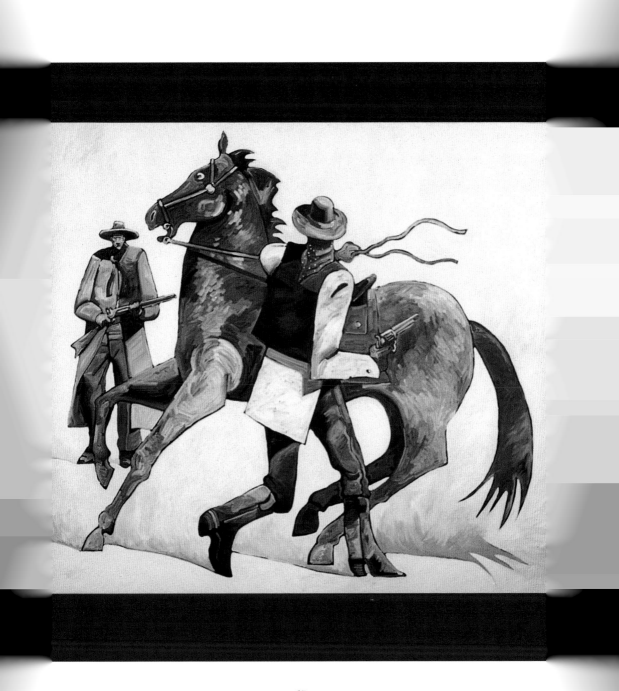

Tom started to run from the lot when Holliday leveled the shotgun at him and fired. The shot hit Tom under his right armpit, but he continued to flee down Fremont Street. Holliday, thinking that he had missed Tom, tossed the shotgun to the ground in disgust and drew his revolver.

At the corner of Fremont Street and Fourth, Tom, mortally wounded, slumped into a bloody heap.

PL. 36. *Tom McLaury Is Dead*
Acrylic on canvas
60 x 40
Courtesy of the Martin–Harris Gallery

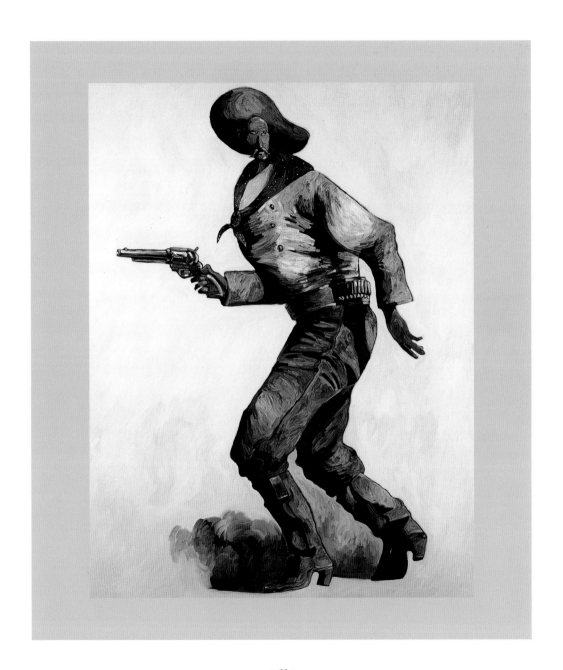

Morgan Earp now struggled to his feet. A bullet from somewhere behind the Earps sailed through the lot and across the street. Wyatt called out that they were being shot at from the rear. Morgan turned to see where the shot came from and stumbled over a mound of dirt thrown up from a recently installed water pipeline, then fell to the ground again. As he rolled over onto his side, he sighted Frank McLaury, now almost across Fremont Street, leveling a gun at Holliday. Frank called out to Holliday, "I've got you now!"

Holliday responded, "Blaze away! You're a daisy if you do!" All three men fired. Holliday's shot may have hit Frank directly in the chest or it may have just grazed it. Frank's shot skimmed Holliday's holster, inflicting a slight flesh wound on his side. Morgan's shot struck the cowboy directly below the right ear, killing him instantly.

PL. 37. *Doc & Morgan*
Acrylic on canvas
48 x 60
Private collection

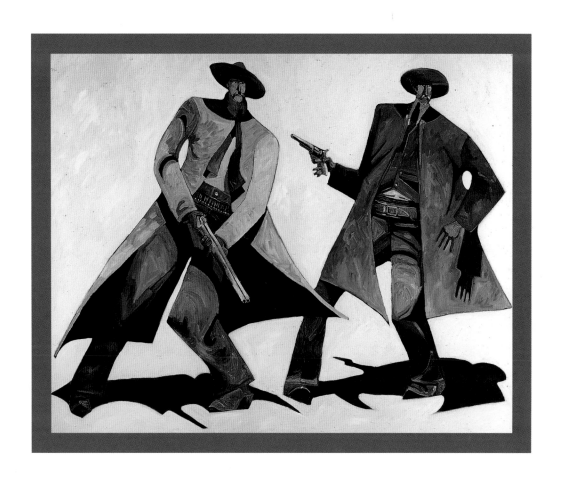

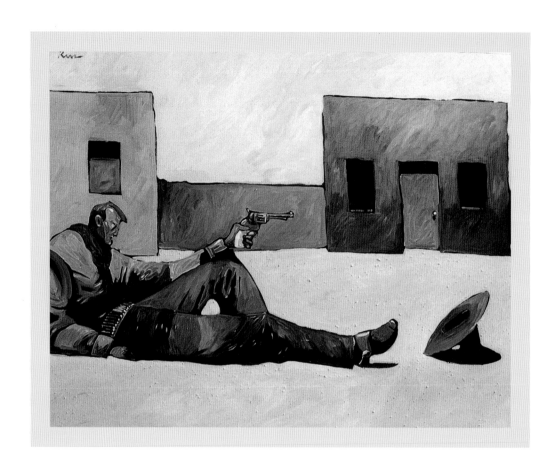

Inside the lot, Billy Clanton was shooting it out with Virgil. Wounded a second time in the right wrist, Billy had to fire his gun with his left hand. He was then hit a third time. This shot struck him just to the side of his navel. He slowly sank to a sitting position, leaning his back against the wall of the Harwood house. Feebly he tried to cock his pistol one last time. Photographer Camilus S. Fly appeared on the scene with a rifle in his hands and instructed, "Take that pistol away from him or I will kill him." When no one ventured close to the barely breathing Billy, Fly walked over and took the gun away himself. The Gunfight at the O.K. Corral was over.

PL. 38. *Billy Clanton's Last Shot*
Acrylic on paper
24 x 32
Courtesy of the Wilde—Meyer Gallery

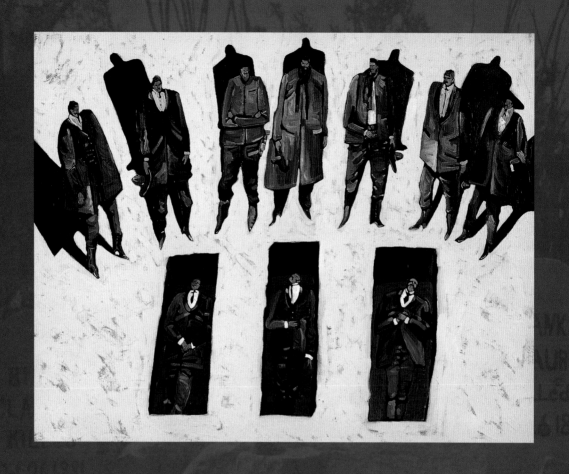

Frank McLaury lay dead on Fremont Street across from the gunfight site. Tom McLaury and Billy Clanton were carried into a house. Tom's eyes moved, but he never uttered a word and soon was dead. Billy Clanton began to writhe in agony. Given morphine, he asked his friend Wes Fuller to "Look and see where I am shot." When Fuller saw the seriousness of the wound, he told his friend Clanton he could not survive it. As he struggled against the pain, Billy cried out, "They have murdered me! I have been murdered. Chase the crowd away from the door and give me air." With a final request of "Drive the crowd away," Clanton went mute and died within a few minutes.

The next day the three men, brothers Frank and Tom McLaury and Billy Clanton, were buried in Tombstone's Boot Hill.

<div align="center">

Pl. 39. *And Die in the West*
Acrylic on paper
30 x 38
Collection of the artist

</div>

 ## Boot Hill

AT THE NORTHERN ENTRANCE to the town of Tombstone sits Boot Hill, the graveyard that holds the bodies of the three men killed in the Gunfight at the O.K. Corral. A fourth member of the cowboy gang, Billy Claiborne, who was killed more than a year after the gunfight, is also buried there. The most famous member of the Clanton gang, Ike Clanton, was killed as he was rustling cattle in 1887 farther north of Tombstone. He was buried where he fell. Descendants of the Clanton family have recently tried to get permission to have his body exhumed and reburied in Tombstone's Boot Hill. Their efforts have, so far, not succeeded. Many of the tombstones in this famous graveyard reflect those tumultuous years of Tombstone's frontier heyday. If you notice the years in which the various deceased met their deaths, you will see that the years 1881 and 1882 seem to have been quite busy ones for the local undertaker.

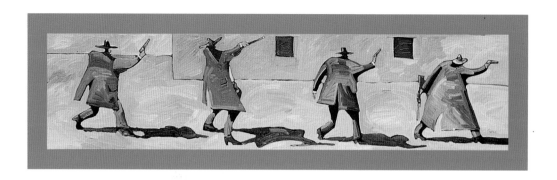

At the trial after the gunfight, Judge Wells Spicer reprimanded Virgil for taking his brothers and Doc Holliday with him to make the arrest of the cowboys; these men were known to be antagonistic toward the cowboys. Hence, he reasoned, the chances for a peaceful arrest were drastically compromised. However, he also pointed out that "as the result plainly proves, he (Virgil) needed the assistance and support of staunch and true friends, upon whose courage, coolness, and fidelity he could depend."

The Earps were found "not guilty" of murder. The outraged cowboy faction, led by "Curly" Bill Brocius, Ike Clanton, and Will McLaury, swore revenge.

PL. 40. *Staunch and True Friends*
Acrylic on paper
16 x 45
Private collection

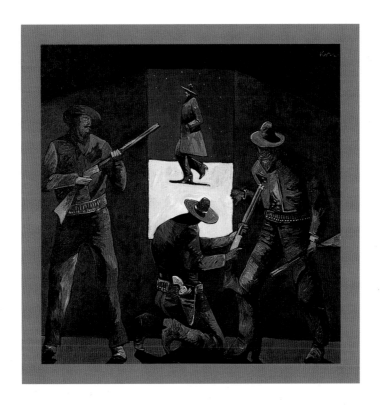

Although the famous gunfight was over, its repercussions lasted much longer. On December 28, 1881, Virgil was doing his nightly rounds of the city, still hobbled by the leg wound he had suffered in the O.K. Corral shoot-out. As he walked along Allen Street, and while crossing Fifth Street, guns roared out of the darkness and Virgil was knocked to the ground, taking wounds to the upper left arm and a scattering of pellet shot to his face. The wound crippled him for life, and though he would later continue with his career as a lawman, his days as one of the "Fighting Earps" were over.

PL. 41. *The Shooting of Virgil Earp*
Acrylic on canvas
36 x 36
Private collection

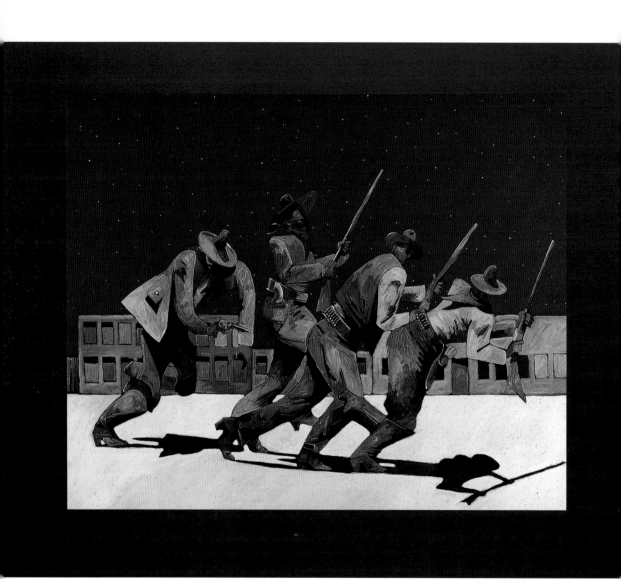

Tensions remained high as the new year, 1882, began. On the night of March 18, 1882, Morgan Earp was playing pool at the billiard parlor of Campbell and Hatch on Allen Street. Watching the game was Wyatt Earp. As Morgan lined up his shot, guns exploded and bullets flew through the windowpanes in the door directly behind Morgan. One of the bullets cut through his spine. He lingered for half an hour before dying.

Wyatt gathered a posse of men he could trust. Doc Holliday, youngest brother Warren Earp, "Turkey Creek" Jack Johnson, "Texas Jack" Vermillion, and Sherm McMasters all joined Wyatt in his quest for revenge.

PL. 42. *Midnight Assassins*
Acrylic on canvas
48 x 60
Private collection

The posse's first job was to get the wounded Virgil, and the body of Morgan, back to their parent's home in Colton, California. The men caught the train at Contention and rode it into Tucson, where they placed Virgil and Morgan's body on a train en route to California. While in the train yard, the heavily armed men happened upon suspected assassin, Frank Stilwell. The next morning Stilwell's body was found lying in the train yard, shot to pieces. Number One for Morgan.

PL. 43. *They Went Looking for Stilwell . . .*
and Found Him!
Acrylic on canvas
48 x 60
Private collection

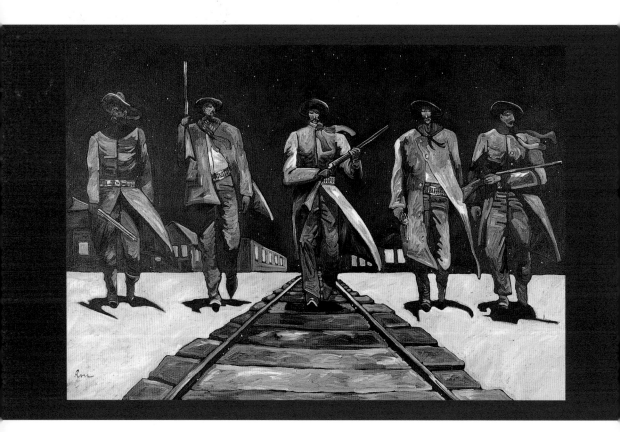

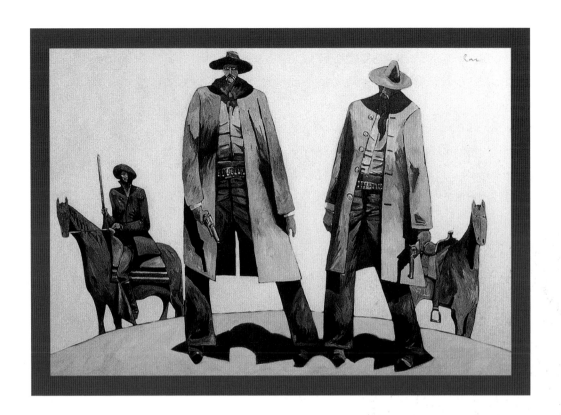

Returning to Tombstone, Wyatt's posse next rode into the Dragoon Mountains, just east of town. They were looking for prime suspect Pete Spence. The men came upon Spence's wood-cutting camp, but Pete was nowhere to be found. As they left the camp, they encountered a man named Florentino Cruz. Earp, who suspected him of being in on the shootings of his brothers, simply killed him.

PL. 44. *Adios, Florentino!*
Acrylic on canvas
40 x 60
Courtesy of the Sutton—West Gallery

Upon their return to Tombstone, Wyatt and his men packed their bags and rode out into the surrounding desert. They entered the Whetstone Mountains, a few miles northwest of Tombstone. As they approached a freshwater spring (variously known as Mescal Springs or Iron Springs), they stumbled upon a group of cowboys getting water. When the startled cowboys jumped into action, Wyatt recognized one as "Curly" Bill Brocius! In Wyatt's account, numerous bullets were fired at him, but none hit him. They passed through the skirts of his coat, and one even knocked the pommel off his saddle. Because it had been a warm day, Earp had loosened his gun holster. Thus, when he tried to mount his pony, he found he couldn't do so because the holster had now slipped down around his legs! In this rather comical position, he grabbed his shotgun and turned to face the cowboys. Over the end of his barrel he could see "Curly" Bill aiming his own shotgun right back at him. Both men fired. Bill missed. Wyatt didn't: his shotgun's blast struck Brocius squarely in the chest, almost cutting him in two.

Although there has always been a question of whether Bill was actually killed there or not, one thing is known: no one ever heard from him again. There is also one account of another cowboy, Johnny Barnes, who was mortally wounded in the gunfight. In a deathbed confession, he stated that Bill was indeed slain by Earp in their shotgun duel.

PL. 45. *Shotgun Duel at Iron Springs*
Acrylic on canvas
24 x 36
Courtesy of the Martin—Harris Gallery

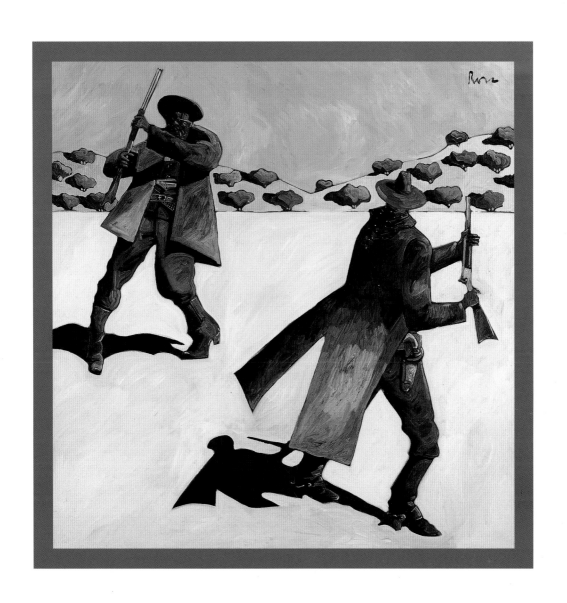

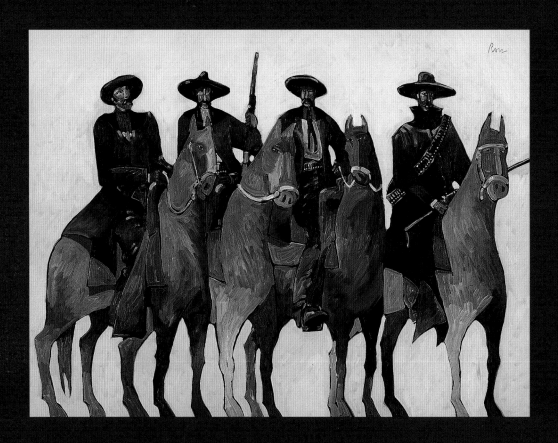

PL. 46. *Riders of Vengeance*
Acrylic on paper
24 x 32
Courtesy of the Wilde—Meyer Gallery

Now with four dead cowboys in his wake, Wyatt Earp rode out of Arizona with his men forever, never to return. Of the fifty years of life that remained for Wyatt, none of them ever caught the fancy or the imagination of the public as did his two years in Tombstone—and especially those thirty seconds in the O.K. Corral.

WHATEVER HAPPENED TO . . .

● **BILLY CLAIBORNE:** With the death of Billy the Kid in New Mexico in July 1881, Claiborne started to liken himself to the notorious outlaw and began to fancy himself some kind of gunman. Calling himself Billy "the Kid" Claiborne, he got into a fight with bartender "Buckskin" Frank Leslie. Leslie, unimpressed with Claiborne's opinion of himself, killed him. As were his pals from the O.K. Corral gunfight, Claiborne was buried in Tombstone's Boot Hill.

● **IKE CLANTON:** In 1887, Ike was caught rustling cattle. Just as he had at the O.K. Corral, he tried to run away, but was shot and killed for his efforts.

● **DOC HOLLIDAY:** After parting from Wyatt Earp in Colorado, Holliday bounced around the West, traveling the gambling circuit and wearing out his welcome in a variety of towns. In May 1886, he finally settled in Glenwood Springs, Colorado, hoping that the sulfur springs located there would help his tuberculosis. Instead, after exposure to the sulfuric fumes, his condition worsened. In November 1887, Doc weakened and he became delirious. On November 8, he woke up and asked for a drink of whiskey. Noticing his bare feet sticking out from under the blankets, he muttered, "I'll be damned . . . this is funny," and died. He was only thirty-six years old.

● **WARREN EARP:** The youngest of the five Earp brothers, Warren was killed in a fight with cowboys in Willcox, Arizona, in 1900. Rumors that his killing was related to the O.K. Corral gunfight were heard but not believed.

● **VIRGIL EARP:** Virgil kept up his life of prospecting and law enforcement. In 1905 he was living in Goldfield, Nevada, when he caught pneumonia and died. A daughter from a previous love affair had his body shipped to Portland, Oregon, where it is the main tourist attraction at the Riverview Cemetery.

● **JOHNNY BEHAN:** Behan stayed within the law enforcement area, working as the warden of the Arizona state penitentiary, and serving in the Spanish–American War. He died on June 12, 1912.

● **WYATT EARP:** Wyatt Earp traveled the West between Los Angeles, San Francisco, and Seattle, even once going as far north as Nome, Alaska. He lived well into the twentieth century. Late in his life, people began to take an interest in the showdown in Tombstone decades before. Early writers, such as Walter Noble Burns and Stuart Lake, helped create the foundation upon which his legend was built. The O.K. Corral gunfight became the most filmed event from the Wild West, appearing in a variety of guises with mixed meanings and very little historical accuracy. It is doubtful that when Wyatt Earp died at the age of eighty-one, on January 13, 1929, he was aware of the towering legend he had helped create and that would persist into yet another century.

BIBLIOGRAPHY

Barra, Allen. *Inventing Wyatt Earp: His Life and Many Legends*. New York: Carroll & Graf Publishers, Inc., 1998.

Bell, Bob Boze. *The Illustrated Life & Times of Wyatt Earp*. Phoenix, AZ: Tri Star–Boze Publications, 1993.

————.*The Illustrated Life & Times of Doc Holliday*. Phoenix, AZ: Tri Star–Boze Publications, 1994.

Burns, Walter Noble. *Tombstone: An Iliad of the Southwest*. New York: Doubleday, 1927.

Burrows, Jack. *John Ringo, The Gunfighter Who Never Was*. Tucson, AZ: University of Arizona Press, 1987.

Clum, John P. *It All Happened in Tombstone*. (Reprinted from the Arizona Historical Review, October 1929.) Flagstaff, AZ: Northland Publishing, 1965.

Etulain, Richard W., and Glenda Riley, eds. *With Badges & Bullets: Lawmen & Outlaws in the Old West*. Golden, CO: Fulcrum Publishing, 1998.

Lake, Stuart Nathaniel. *Wyatt Earp: Frontier Marshal*. Boston: Houghton Mifflin Co., 1931.

Lamar, Howard R., ed. *The New Encyclopedia of the American West*. New Haven, CT: Yale University Press, 1998.

Marks, Paula Mitchell. *And Die in the West: The Story of the O.K. Corral Gunfight*. New York: Morrow, 1989.

Martin, Douglas D. *Tombstone's Epitaph*. Albuquerque, NM: University of New Mexico Press, 1953.

Tanner, Karen Holliday. *Doc Holliday: A Family Portrait*. Norman, OK: University of Oklahoma Press, 1998.

Tefertiller, Casey. *Wyatt Earp: The Life Behind the Legend*. New York: John Wiley & Sons, Inc., 1997.

Turner, Alford E., ed. *The O.K. Corral Inquest*. College Station, TX: Creative Publishing Co., 1981.

Waters, Frank. *The Earp Brothers of Tombstone*. New York: Clarkson N. Potter, 1960.